No-Copy

Advertising

Lazar Dzamic

No-Copy

Advertising

Lazar Dzamic

design:

Slavimir Stojanović // FUTRO

Published and distributed
by RotoVision SA
Rue du Bugnon 7
CH-1299 Crans-Pres-Celigny
Switzerland

RotoVision SA
Editorial & Sales Office
Sheridan House
112/116A Western Road
Hove, East Sussex
BN3 1DD, UK

Tel. +44 (0) 1273 72 72 68
Fax. +44 (0) 1273 72 72 69
Email: sales@rotovision.com
Website: www.rotovision.com

ISBN 2-88046-566-4

10 9 8 7 6 5 4 3 2 1

Book design by Slavimir Stojanović // FUTRO

Production and separations
in Singapore by ProVision Pte. Ltd.
Tel. +65 334 7720
Fax. +65 334 7721

for Dana

Acknowledgements:
Any book of this kind is a collective effort. Therefore I owe gratitude to many people who have helped me finish the project. Above all to: Luke Mitchell, initial editor of the book, who adopted and nurtured the idea; Natalia Price-Cabrera, Editor-in-Chief at RotoVision, for additional boosting of morale, exceptional kindness and masterful editing; Bob Garfield, whose friendship meant a lot In some rough life moments; Slavimir Stojanović, for the impeccable book design; Neil French, Trevor Beattie and Jack Fund for allowing themselves to be interviewed; Richard Muyers and Dragan Sakan, for early support; Marina Vasiljevic and Vana Goblot, for calling and liaising with agencies; David Graham, Emily Shaw and CCC for co-ordinating the screengrabs of the TV ads; my people in Ehsrealtime for giving me the freedom to be myself; and finally, all of the agencies' executives, PAs and PRs for putting effort in chasing work, credits and creatives.

No-Copy

Advertising

Contents

Foreword by Bob Garfield

A picture, as it turns out, is not worth 1000 words. This I know for sure, because I proposed to the publisher of this volume that my contribution should consist of my photograph and one of those comic-strip dialogue balloons superimposed on it. And the balloon would be empty. Get it? A no-copy foreword. "Very witty," the book people said. "Very post-modern. But we'll take the 1000 words."

Fine. Nine hundred and twenty-two to go.

But I accept the challenge gladly, because Lazar Dzamic is on to something here, something big. No-copy ads are not merely a phenomenon in advertising, they are a mega-trend. Used to be, printed advertising was divided into press and outdoor. Press was what you found in newspapers and magazines, outdoor was on walls and highway billboards. Outdoor was always very simple, because it was aimed at passers by, some of whom pass by at 150 kph. Well, nowadays there barely is a press category. At international festivals and increasingly in the real media world there is only magazine-sized outdoor. If copy isn't dead, it's certainly in its death throes.

Persuasion and information are relics. If an idea—or, more accurately, a visual joke—can't be expressed with a photo that wittily conveys a single brand attribute, the ad is not apt to get made. This development is either good or bad, or maybe neither, but it is certainly easily explained. For starters, there is a trend in the culture at large away from the written word. The MTV generation may not be illiterate, but it is dangerously, like, aliterate. Language is out; provocative images are in. In western society we are busy and impatient and we demand instant gratification. Language takes too long to download. Number two is globalisation. As advertising increasingly crosses borders, it becomes harder and harder to communicate with words. Pictures are a universal language, and though they may be able to express only less complex ideas, they communicate them without misunderstanding. Thirdly, there is vanity. It is very difficult to win an international advertising award using what hitherto had been the stock-in-trade of clever advertising—namely, clever writing. Too much is lost in translation, especially in

humour, and the inspired cultural allusion or turn of phrase may confuse the Latvian judge. Want to win gold trophies? Check your lexicon at the door.

I might add one fourth explanation. When properly executed, as you shall see in the forthcoming pages, no-copy advertising is irresistible. In a craft that places a premium on simplicity, potency and purity of idea, there is hardly anything to compare to no-copy's vivid impact. I call your attention to the Mercedes SLK work: an eye-catching sports car, parked at a curbside, on a road blackened with skid-marks from passing vehicles whose drivers braked suddenly to gawk. It is a masterpiece, lionised in 1998 with the press grand prix at the International Advertising Festival in Cannes. This was not lost on the profession.

However, from the short but safe distance where I observe these things, it strikes me that the advertising world itself is a bit conflicted about the trend. This is an industry which, after all, was built on words. Words of information. Words of persuasion. Words of self-promotion. Words of flattery. Words of promise. Words of caution. And many, many, many words of utter misrepresentation.

The most famous advertising of all time is revered not for the images that accompany the headlines, but for the headlines themselves. "They laughed when I sat down at the piano." "Does she or doesn't she?" "We try harder." "Labour isn't working." "A diamond is forever." "Lemon." Virtually every creative department in the world is organised around teams of art directors and copywriters. Not "idea havers". Copywriters.

Not to put too fine a point on it, without words there would have been no way to express the observation that "at 60 mph, the loudest sound you hear is from the electric clock." To be sure there must be non-verbal ways to convey "quiet ride." But not that particular way, and upon that particular way David Ogilvy built an empire. And a philosophy. And a legend.

Thus the dilemma: on the one hand, how can you not admire the ingenuity, the purity, the elegance, the silent eloquence of the Mercedes ad? Just as no graven image alone

could express Ogilvy's chronometric single revealing detail, no ten words or 10,000 could convey the stop-in-your-tracks curb appeal of the SLK—at least, not without violating an inviolable taboo. For Mercedes to verbally present a $65,000 SLK as some sort of vulgar trophy—an automotive version of the blonde bimbo with the implants—is unthinkable. People may understand the car to be the object of envious stares, but this must not be uttered aloud.

How convenient to be able to communicate the idea without actually saying it. The difference between taboo and genius? A technicality. On the other hand, how can you not, in a profession so steeped in language, embrace wordless advertising without feeling, in your heart of hearts, that it is some sort of surrender, that persuasion is being sacrificed at the altar of simplicity, that muteness is some sort of tragic mutation?

Never was the ambivalence more obvious than in 1999 at Cannes. A year after SLK's triumph, the press/outdoor grand prix went to another no-copy ad, this one for Playstation. It depicted a teenage boy and girl in tight t-shirts, their nipples straining against the fabric. But instead of the expected protuberance were the symbols + - x o—i.e., the key icons found on videogame controls, a quartet of subliterate glyphs. A non-verbal ad in celebration of the non-verbal culture.

Fair enough. But then came the TV grand prix, a 60-second spot consisting of no fewer than 130 words (the average spot has about 30) in an emotional broadside against the forces of reaction, repression and above all aliteracy. It was for *The Independent* newspaper. The prescription for battling ignorance and intolerance? Read.

Thus is advertising something like a novitiate being dragged, kicking and screaming, to the chapel to take her vow of silence. But take it she shall, because the world isn't getting less globalised; it is getting more so. Culture isn't getting more literate; it is getting less so. There aren't fewer advertising awards shows; there are more of them. And no-copy advertising isn't necessarily causing problems; often enough, as you are about to discover, it is brilliantly solving them.

To some they are the Holy Grail: the highest form of advertising mastery and skill. To others they are despicable; gross examples of creative excess and self-indulgence (or "art sponsored by client's money" as someone once put it). Whichever description you prefer, there is no arguing with this fact: No-copy ads ("minimum-elements ads", "reduced ads", whatever you want to call them) are maybe the most poignant, controversial and intellectually gratifying experience modern advertising has to offer.

Defined loosely as adverts with no or just a minimum of text (maybe a tagline or just the name of the product advertised) no-copy ads rely solely on visual elements as their persuasive weapon. Pictures or illustrations accompanied by the client's logo are the only means of attention-grabbing and desire-building. No-copy ads ought to prove that one picture, indeed, is worth more than a thousand words.

With their reliance on visual symbols and clues, no-copy ads give the impression that we are truly living in a visual civilization. In this day and age, when the highway of messages on route to the average consumer is becoming increasingly cluttered, there is a fight for a new road. They carry with them the underlying dichotomies of our age: spiritual and material; art and selling (or selling off); mass and elitist culture.

No-copy ads ask more questions than there are answers to give:

Are they the most awarded ads at advertising festivals across the world because they're a way for the advertising industry to give itself a pat on the back, or because they are what all advertising will become one day when it grows up? Do they demand too much brain-processing effort to be effective in today's marketplace, or do they represent a very gratifying experience for the intelligent consumer?

Are they complicated pieces of work too puzzling to be deciphered quickly, or cunningly conceived messages that increase interaction time with the consumer?

Can they break through the clutter with their strangely appealing minimum elements more effectively than the information-packed stimuli that surround them? Can they sell? Can they actually move products off the shelves or are they just a top-of-the-line image differentiation brand-building exercise?

I like to think of a no-copy ad as a mysterious stranger in a bar. Someone story-tellingly: quiet, different from the rest of the crowd by that hazy look in the eyes. Someone who, with their posture and look, radiates a much deeper history. Decide to engage them in conversation and try to find out what the mystery is, and if their story is satisfying, get the feeling of solving their puzzle. Get blessed with an intellectual reward, with insight, with a sharing of wavelength and, subsequently, with a feeling of closeness. Can you think of a more ideal model of advertising effectiveness?

This book represents a collection of some of the most revered ads in recent times and is also the first one to deal exclusively with no-copy ads. Every ad has won at least one major advertising award, some of them have won several. Many have changed the way that advertising is perceived in specific industries. All of them demonstrate the challenge, complexity and ingenuity of their ideas. They are percolated inspiration for every advertising professional and meaning-seeking student, and they show the immense power of the "visual".

Somehow the story of letters and words has come a full circle. It started with pictorial symbols in old Egypt, hieroglyphs being the most notorious example. It finished with a new pantheon of graphics representing new gods—multinational brands. The new lingua franca of our global civilization is not English, it is the logo, the picture, the image. And almost all of us, no matter where in the world we are living, speak it fluently.

Words or pictures, or pictures of words?

TREVOR BEATTIE, NEIL FRENCH
AND JACK FUND—INTERVIEWS

Neil French

Trevor Beattie

Jack Fund

If there is one strong aspect in no-copy ads, it is that they divide the opinion of advertising professionals. That's why it is so interesting to see what different top players think of them. The same set of questions has therefore been posed to Trevor Beattie, creative director of London's TBWA, Neil French, creative director of Ogilvy & Mather, Singapore and Jack Fund, creative director of L.A.'s Jack agency. All of them have some of the most respected ad careers of our time and their answers here are almost a small school of advertising in their own right. However, differences are huge. Three different personalities. Three different views.

Let's start with a broader framework: many claim that we are living in a visual world; pictures and visual symbols are actually the lingua franca of modern civilisation, not the English language as is usually considered. What do you think about it? Is there any truth in this claim?

T.B. Yes and no. The internet appears to be run on words. English (or should that be American) words.

J.F. Visual symbols have always been the first language. Even before we were civilised. There weren't words drawn on the walls of prehistoric caves to describe the day's events. There were pictures. I ask you, is man fundamentally that much different today?

N.F. No truth at all. We still talk to one another...we don't wave pictures.

Has globalisation brought about the increasing number of no-copy ads or is it a result of a more sophisticated audience? Something else?

T.B. Fashion. Creative laziness. Visual-only ads aren't necessarily "sophisticated".

J.F. There's no question that some global brands use all-visual executions to transcend cultural borders. But I think maybe it's more a matter of trying to stand out. I mean, there's so much visual pollution in magazines and

newspapers these days. It seems like an obvious solution. Also, as a whole, I think society is moving faster and faster. Technology and the demands of a modern world are pushing us to do more things, more quickly. Mobile phones and laptop computers allow us to work anywhere. We can be reached anytime of the day or night by e-mail, faxes and pagers virtually anywhere on the planet. Time has become our most valued commodity. People are not willing to give it up freely to things that are complicated to understand and digest. For better or worse, we are living in drive-thru', fast food, mini-mall times. Please pull forward.

N.F. Yes: it's a symptom of laziness, and of illiterate admen.

What has happened to the old maxim that advertising is "salesmanship in print"? Apart from being dubious because of TV, radio and the internet as ad channels, how does this "hard sale" school compare today?

T.B. Advertising is salesmanship which entertains.

J.F. I think the print medium is still considered a "hard sale" tool. Especially by retail businesses. But you have to ask yourself, if everyone else is screaming at the top of their lungs, do you need to yell just to be heard? Or is there another way? Maybe if you lower your voice to a whisper, you can actually stand out from the pack.

N.F. Advertising is still salesmanship. Anyone who thinks differently is taking client's money on false pretenses. You are known as one of the most prominent champions of the stripped-down approach in creating ads. How did that develop?

T.B. Slowly.

J.F. Early on, I landed a copywriting job at Rubin Postaer & Associates working on Honda, whose work at the time was some of the best automotive advertising in the industry. Although at that point no longer on ads, Honda's credo was "We make it simple."

That really stuck in my head. Not so much as a tagline, but as a way of thinking. You know, stripping a brief down to one sentence, sharpening the consumer take-away to a singular point, crafting an idea to its purest form. I think that's when an ad can become art.

N.F. "Less is more" is not the same as no-copy. I believe in cutting out everything that does not contribute to the ability of the consumer to grasp the point of the ad. Sometimes, the best thing to do is cut out the picture entirely and rely solely on copy. I've done plenty of ads that do exactly that.

Let's take readers of the book through some "reduction" exercises: where do you usually start regarding the classical structure of an ad and where do you try to get to at the end?

T.B. Everything in the ad must justify its existence. Everything else gets fired.

J.F. I suppose convention would have it that an ad needs a visual, a headline, body copy, a logo and a tagline. Oh yeah, and a mouseline of legal type. I start by asking myself questions. Can the visual be the headline? Can the logo be part of the visual? Can the tagline be the logo? Does the ad really need body copy to drive its message home? Can we kill all the pesky lawyers who make us add disclaimers to ads? The bottom line is, how many elements can we eliminate and still have a strong piece of communication?

N.F. I just look at an ad and ask if every element is contributing, and then I throw out anything that isn't doing so. The key is not to believe that an ad has to have any particular element. All we have to do is communicate with the reader…by any means at our disposal.

Any specific name for your "method"?

T.B. No

J.F. Common sense.

N.F. No

In a way, we are claiming here that the fewer elements we have in an ad, the more engaged the beholder could become?

T.B. When it comes to ads, less genuinely is more. Life's too short to read adverts. There are much better things to do. Sex, for example.

J.F. I was just thinking that a minute ago. Ironic, isn't it? But it's true. People don't have time for corporate blather, no matter how important advertising managers and product people think their copy points are. I mean, what good is a double-page spread filled with copy if the reader flips right past it? That just seems reckless to me. Frankly, ads that don't look like ads interest people. They try to figure out what you're trying to say. And when they figure it out, they feel either rewarded or jipped for their effort, depending on how clever the ad was. So if you do your job right, you can get a reader to spend time with your handiwork and actually connect with them without using a single word.

N.F. No, we're not saying that. We're saying that by excluding anything that does not contribute, we're making it easier for the "beholder" to understand and enjoy the point we want to make. This usually means fewer elements, rather than more of them. But not always. There are times when one realises that more examples or explanations would be more engaging and convincing.

Aren't no-copy ads challenging, sometimes too challenging for the common consumer? Are they maybe an elitist product for an elitist public, which could explain why this sort of ad is usually heavily awarded at advertising festivals?

T.B. Ads are rarely too challenging, but they're often elitist. I'm no big fan of advertising awards. I value the reward of people talking about my ads and buying my product way above the approval of my peers.

J.F. I see your point, but I think the problem with a lot of no-copy ads is that there isn't a strong idea to begin with. And when there's no idea, it's easy for readers to get confused. Ninety per cent of the ads I see confuse me. I think if an idea's compelling, it's compelling. Whether it uses lots of words or none at all. Whether you're an award show judge or a guy on the street.

N.F. On the contrary. They are all too frequently the result of lazy thinking, and

aimed at an instant reaction, rather than being aimed at the psyche of the consumer. And they tend to win awards because award-juries tend to be made up of people whose sense of self-importance has been flattered by their inclusion, but who are shamefully aware of their shortcomings as salesmen. These people can more easily award a slick, glib, picture idea than take the time to read an argument and put themselves in the shoes of the consumer at which an ad is actually aimed.

These ads often work on the level of a puzzle or a pun, and have to be deciphered. How does one create the right amount of suspense so that the viewer gets that "a-ha!" feeling?

T.B. It varies ad to ad. Audience to audience.

J.F. Anything you can do to make an ad "interactive" is a good thing. As long as it's relevant to what you're selling. I mean, there's probably not much sense in creating a cross-word puzzle ad for an aerospace client trying to sell an airborne early warning defence system. On the other hand, I once did a Honda ad that featured 62 vanity license plates that people had to figure out. It ended up being pretty famous. The difference is the idea was rooted to the product.

N.F. Precisely my point. Too often the code is known only to admen!

Leo Burnett once said that an ad should let the consumer "finish a line" when interacting with it. But, where's the line between having a "lean and mean" ad and an unintelligible one?

T.B. I hate people who quote ad people. Ad people aren't worthy of being quoted.

J.F. I think I'd have to disagree with Leo. An ad still needs to be self-contained. Some ads can get the idea across with a single photograph or illustration. Others need to be more complex. It really depends on the concept. But regardless of which approach is taken, everything should be there for a consumer to discover, be it implicit or explicit. If you leave it too open-ended, often a consumer won't get it. Or worse. They'll fill in the blank with the wrong answer.

N.F. Again, your question answers itself, I think!

Aren't no-copy ads a little paradoxical? People have less time for interacting with advertising and, yet, no-copy ads demand certain time to be understood. Are they good in attracting attention?

T.B. Of course. No-copy ads shouldn't require more time to be understood.

J.F. Of course. It's really just a matter of biology, isn't it? The eye feeds information to the brain so that it can respond. You know, caveman sees hungry dinosaur, caveman runs like hell. We are a visual culture. Watch the average person shop for wine in the grocery store sometime. You think they read the label?

N.F. I think they attract attention. But then either they are too gnomic to reward further time being spent on them, or they have no substance beneath the visual. Long copy ads need more time to be spent on them, but if well written, yield a more satisfying reward. The time required to enjoy the argument is rarely available in award-judging, even if the judges themselves are not illiterate...hence long copy is not awarded.

OK, let's assume I'm an ad creative who would like to sharpen up his skills of making such ads. What should I be doing? Where's this coming from? Can it be learned?

T.B. Never study other ads. Learn from life, not ads.

J.F. Just about anything can be taught I suppose. But it's not easy. I used to coach a junior high basketball team for a couple years when I was in college. At practice, I'd have my players play an entire game with no dribbling. They were forced to pass to their team-mates, something they were not predisposed to do. Guess what? It took a little time, but they learned teamwork. The same principle can work with coming up with all-visual ads. Pretend you can't use any words. Or pretend the print ad you're working on is a billboard. You need to be clear. You need to be relevant. You need to be quick. And above all, you still need a big idea. You need to tell a story.

N.F. All any adman has to do is to understand the consumer and then speak to him in an appealing way. Trying to produce a certain

kind of ad is counter-productive.

Knowing the usual corporate client, one can predict a very tough time for a creative team trying to sell the minimalist idea to a bunch of people whose main advertising aim is to see the name of the company or a product repeated as many times as possible. What are the usual issues that clients have with stripped-out ads?

T.B. Some people believe in formulaic work. I don't trust the tried and tested.

J.F. Clients have boxes. Boxes that need to be checked off. And if they're not checked off, someone's not doing his or her job. Often a client will feel that if an ad doesn't include everything there is to say about the product, it's not working as hard as it could. And in these competitive times, some clients get scared. But they're actually doing themselves a disservice. A single ad is just an entry point. It's really the beginning of a dialogue. It's only part of the communication mix. If all you had to do was run an ad that included everything but the kitchen sink in extra bold, clients wouldn't need agencies. But it doesn't work like that. I think the smart clients out there know that.

N.F. Oddly enough, I think it's easier to convince a client to accept a "stripped-down" ad. If the idea is more obvious, the client will more easily understand it (as will the consumer) and stuff that gets in the way will be seen as pointless and silly. This always assumes that the idea is good enough in the first place. If an idea is weak or non-existent, the more stuff the client puts in, the better...it'll hide the inadequacy, and the incompetent adman can blame the client.

Can no-copy ads sell?

T.B. Of course. What a ridiculous question. Can all-copy ads sell?

J.F. Good ones can.

N.F. Posters can sell. So, in some cases, yes.

So, what about the future: are we going to see more and more no-copy ads?

T.B. No. Not in the long run. It's a trend.

J.F. I hope we just see more new ideas. And if they're visually-driven, all the better. But only until everyone is doing it that way. And then I'll go back to writing long-copy ads again.

N.F. Probably. The standard of thinking in advertising is lower than at any other time in its history. But to understand and enjoy the web, you have to be literate...so I predict an increase in literacy (of a sort), an increase in book sales and gradually (because advertising is notoriously reactionary), an increase in the intellect and ability of creative people.

Final question: if someone gave you the power to condense advertising as a method of communication into just one element, what would you choose—a picture or a word?

T.B. A picture of a word. The word "Hello".

N.F. I wish I could give you a straight answer, but I can't. Sometimes a picture is the most important element in an idea, sometimes the words are. Take Trevor Beattie's f.c.u.k. ads: the pictures are relatively unimportant. They are copy ads, even if there's only a bit of copy or a few initial letters. The Benetton ads are all-picture, and are crap, because they rely entirely on the power of the picture to shock...leading the client to alienate more consumers than they attract. Take the Blackcurrant Tango TV spot...an amazing bit of camera-work and direction, but it's the script that makes it funny and appealing. Try running any great TV ad with the sound turned down and you'll see the need for words. Nike's "Good vs Evil" is one of the few exceptions. I'd say that all the greatest ads in the world rely on words as their foundation...even if the words are few. All we do, at best, is communicate: we have senses of smell, hearing, taste, vision, and touch. Generally, advertising relies totally on hearing and seeing. We need to maximise the power of our ability to communicate in both these areas to succeed. So, words and pictures for the eye, and words and music for the ears, all combine to make a point. But the prevalence of one element makes it easier for the consumer to give us his full attention.

J.F. I don't know. What's more powerful, Christ on the cross or the Bible?

Still pictures

& pictures in passing

Advertising

PRESS & POSTER

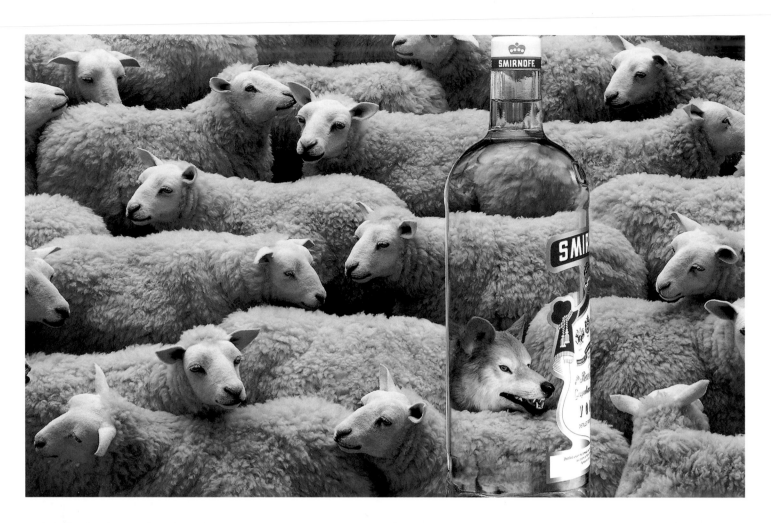

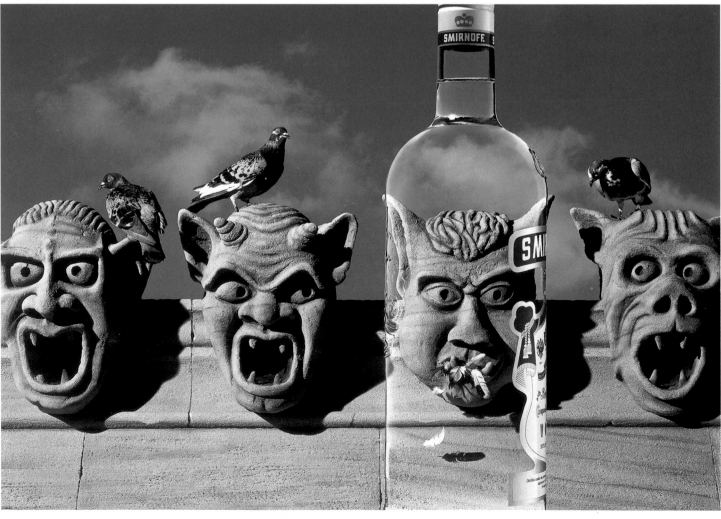

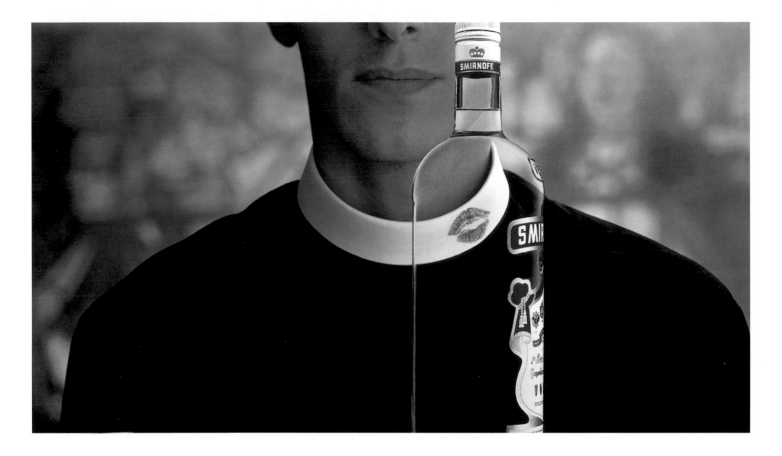

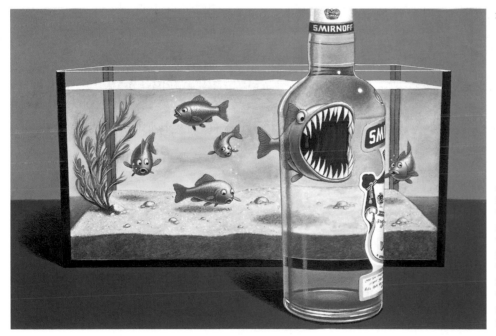

AGENCY: Lowe Howard Spink London
Creative Teams:
"Wolf"—Kevin Jones & Paul Jones
PHOTOGRAPHER: Paul Bevitt
"Gargoyles"—Paul Falla & Brian Campbell
PHOTOGRAPHER: Mike Parsons
"Priest"—Sue Higgs & Wayne Hanson
PHOTOGRAPHER: David Scheinmann
"Goldfish"—John Merriman & Chris Herring
PHOTOGRAPHER: Mike Terry/Folio
CLIENT: UDV/Smirnoff

WOLF
GARGOYLES
PRIEST
GOLDFISH

An older and very famous relation of today's no-copy campaigns, and a series that has run for years and delighted not just admen, but smart-thinking and pun-loving people all over the world. It has had literally hundreds of executions, thanks to its format that can be replicated and perpetually developed. It was a global campaign *par excellence*, translating very well across different markets and getting many hilarious or even strange local executions (see page 19 for an example). Without exaggerating, we can say that this would be a template for a successful no-copy campaign, achieving all of the benchmarks of quality advertising: brand building, differentiation, sales, global expansion... A great example of a pure, big idea at work—ads didn't even show the full brand's logo, only half of it. Very brave, even by today's standards!

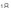

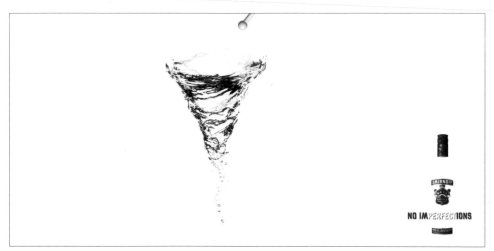

TWISTER
TOMATO JUICE
CUBES

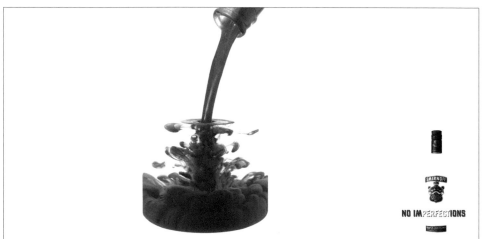

AGENCY: JWT London, 1999
COPYWRITER: John Donnelly
ART DIRECTOR: Ken Grimshaw
PHOTOGRAPHER: Gary Bryan
CLIENT: UDV/Smirnoff

I can hardly imagine a tougher act to follow. The first sequel to the globally famous and multi-awarded campaign from the previous pages had the same destiny as Pink Floyd's first album right after *Dark Side of the Moon*—as a stand-alone product, it was bloody good. The dramatisation of maybe the only USP that vodka can offer (except the lack of a distinctive or unpleasant aftertaste), namely being the clearest alcoholic drink possible, makes this campaign a textbook example of how to do it right. We can't see the product, we can't even see the product package, but we can imagine it, we can build on a projection of "clearness" and in this lies the beginning of desire. Great advertising skill: making it more appealing by not showing it. "The brief was to communicate the total purity of Smirnoff. We achieved this by dramatising the fact that the vodka is so pure it can't be seen. All that was left to show were the additions—the tomato juice, the ice cubes and the swirl from a swizzle stick. Even the bottle and endline were designed to emphasise the purity of the product." Ken Grimshaw

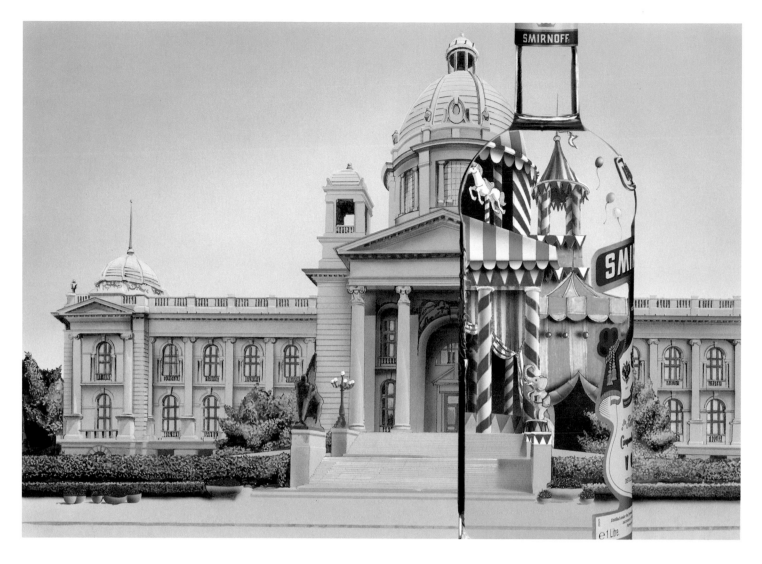

FEDERAL PARLIAMENT

AGENCY: ICPS—Infinity Belgrade, 1997
COPYWRITER: Vladimir Milanovic
ART DIRECTOR: Slobodan Jovanovic-Coba
CLIENT: Pierre Smirnoff Co.

It is not often that advertising can be accused of having true relevance to the political life of a country. But this ad is one example of this. It represents the Yugoslav parliament, which through the Smirnoff bottle—a local implementation of the legendary campaign—turns into a circus. It was developed during the Yugoslavian "winter of discontent" ('96/'97) and symbolises the overwhelming anger of the people towards their government. The ad, bizarrely, remained relevant until October 2000 and the Yugoslav revolution in which the parliament building was the first to be taken over and set on fire! The circus was over. "The idea was to depict Belgrade in a typically Smirnoff way—as a place which is able to inspire and motivate artists to debate and represent their city in an ironic manner. Considering the situation in the country, more than 60 per cent of the solutions were influenced by politics. In order not to attract the rage of unpredictable politicians, we tried to moderate a little the social issues present in the solutions which described very precisely the chaos that surrounded us. That is the reason why the parliament building too is represented as a drawing which, due to its almost comic book-like form, diminishes the edge which a realistic picture would have. Thanks to the framing and of course the message through the bottle, the idea remains fresh. The fuss made after the ad was published and even banned, made us realise that we had achieved the effect we had in mind. The thrill which working on this ad brought about is certainly what makes this job interesting and inspiring." Slobodan Jovanovic-Coba

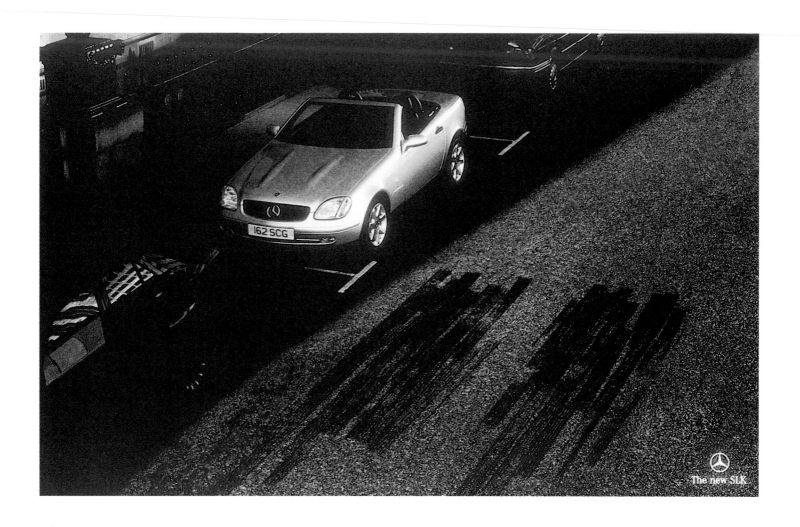

SKID-MARKS

AGENCY: Leo Burnett, London, 1998
COPYWRITER: Nick Bell
ART DIRECTOR: Mark Tutssel

Just read Bob Garfield's thoughts in his foreword again on this piece of advertising history... "Skid-Marks" is one of the most awarded ads of our time and maybe the best example of the power of no-copy advertising.

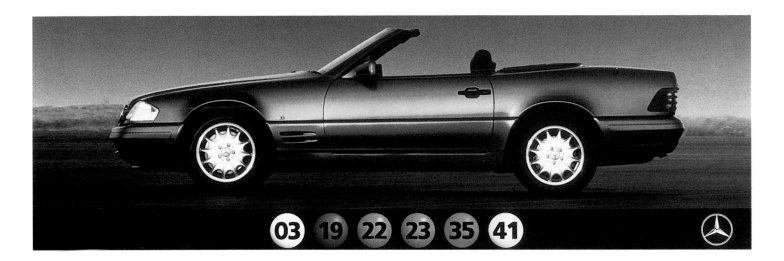

LOTTERY BALLS

AGENCY: Leo Burnett, London, 1998
COPYWRITER: Nick Kidney
ART DIRECTOR: Kevin Stark

A reoccurring problem with no-copy ads is that sometimes they are so subtle one needs a translator to decipher the message. It was the case with "Skid-Marks", and it is the case with this ad. Sporting one of the most beautiful profiles ever seen, the message mechanism is extremely delicate. At first it might even seem plain arrogant ("only people with money can have this baby!"), but a detectable hint of self-irony keeps its feet firmly on the ground. Class, style exclusivity and humour are what this ad is all about. So many things are crammed into one picture. "The lottery was about two years' old when we did the ad," says Nick Kidney. "The idea came from a chat with a Mercedes dealer who told us he'd just sold an SLK to a lottery win. On further investigation we discovered he wasn't alone. In fact the car was one of the most popular choices for people who suddenly found themselves with millions in the bank. The problem was that writing a headline to that effect seemed too self-congratulatory. Instead, we decided to show it and let people work it out for themselves."

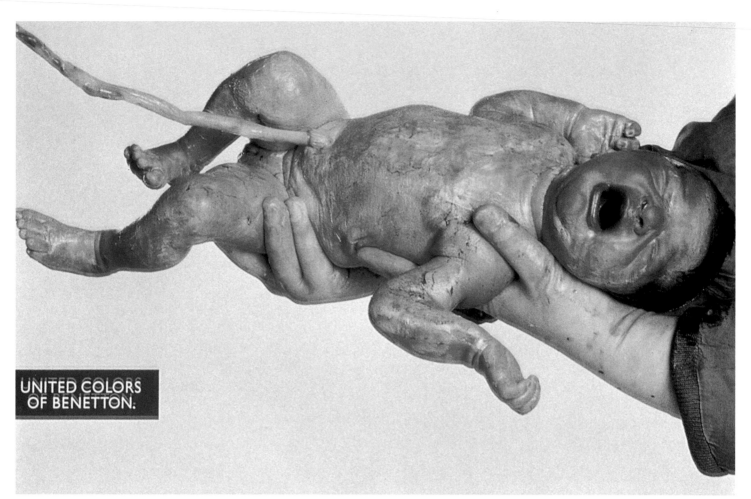

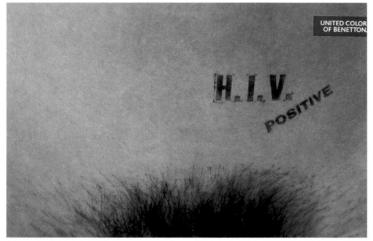

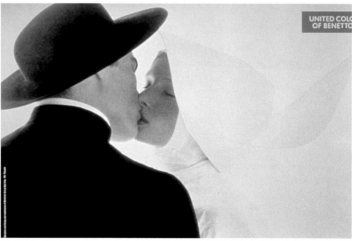

BENETTON VARIOUS WORKS

PHOTOGRAPHY/CREATIVE DIRECTION: Oliviero Toscani
(works presented date from 1989 to 1994)
CLIENT: Benetton

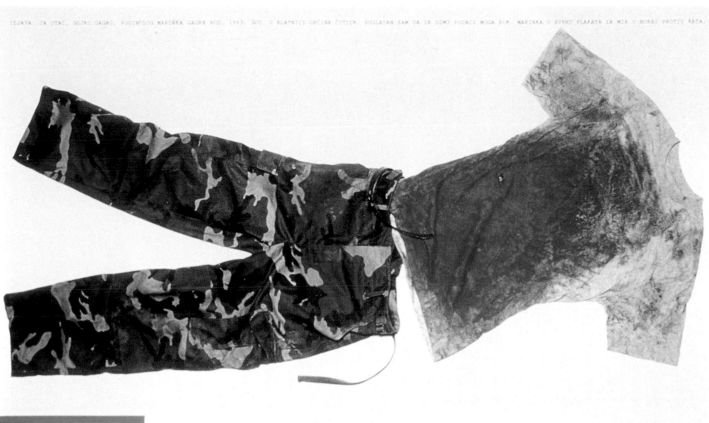

UNITED COLORS OF BENETTON.

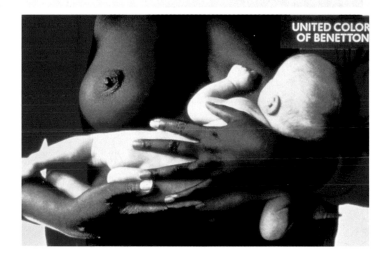

Maybe the world's most famous purely image-based campaign, completely transcending the realm of advertising and showing that what is usually considered a selling tool can be elevated to a powerful social issue. Each of these posters sparked controversy, verbal fights between admirers and opponents and reaction by some of the most powerful and prominent organisations and individuals on the planet. For some, this was blatant abuse of shocking tactics for peddling clothes. For others, a strong social statement of a society-conscious company and an artist. In all of that furore, one fact went unmentioned: all these pictures show the most ordinary facts of life. In their most raw form, maybe, but still the most ordinary facts. Which poses a question: what kind of a society can have a problem with such fundamental truths as a picture of a new-born baby? The campaign was a giant mirror, showing how hypocritical, lost and prejudiced we have become.

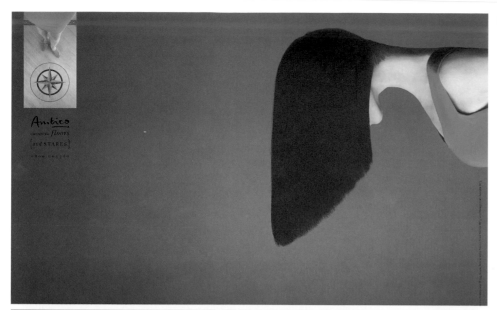

AMTICO FLOORS

AGENCY: Banks Hoggins O'Shea/FCB London, 1997
COPYWRITER: David Alexander
ART DIRECTOR: Rob Fletcher
PHOTOGRAPHER: David Stewart
CLIENT: Amtico Flooring Company

Having a style-conscious client is a dream for any creative team. It allows you to really stretch your creative muscles and come up with subtle and unexpected solutions. In this campaign, the change of a point of view happened almost literally. David Alexander explains why: "Amtico is a design conscious flooring company with a history of mould-breaking advertising. It is, however, an expensive product that naturally attracts older, more affluent customers. To keep Amtico at the cutting edge of design, our job was to give the floors iconic status among younger buyers. The floors are so good that many people consider them works of art. So it wasn't a big leap to imagine a stylised art gallery where the people were looking at the floor instead of the walls. The ads simply extended the theme of people distracted by the floor."

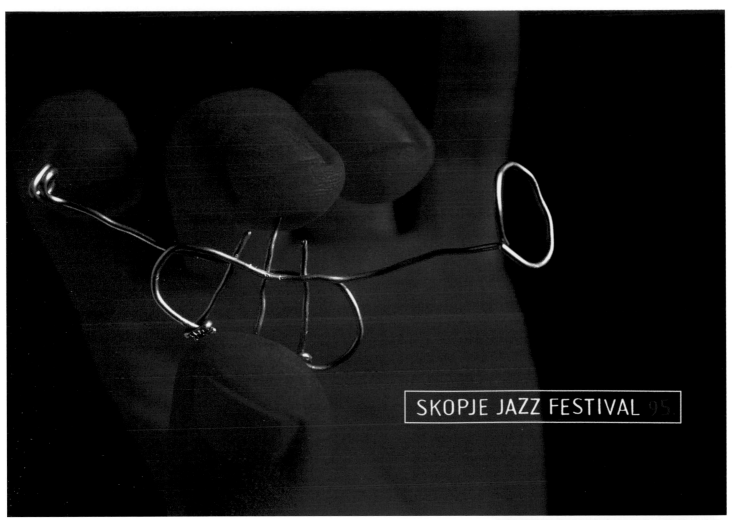

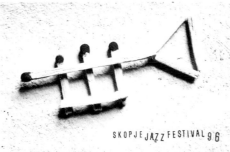

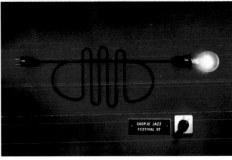

SKOPJE JAZZ FESTIVAL POSTERS

AGENCY: S Team Bates Saatchi & Saatchi Balkans, 1995/96/97
COPYWRITER: Slavimir Stojanović
ART DIRECTOR: Slavimir Stojanović
PHOTOGRAPHERS: Ivan Šijak, Aleksandar Kujučev
CLIENT: Oliver Belopeta, Skopje Jazz Festival

It's hard to capture in print the true spirit of such an anarchic art form as jazz. Usually, it is the angle of photography or experimentation with colour and font that is used to convey the feeling. The series of posters presented on this page is a triumph in symbolism and symbolic mastery, of highly skilful use of a "sign". They're slightly surreal in appearance, especially when you consider the materials used for the models. There isn't a single thing here that is scenario-based, no puns that could be verbalised (try explaining one to a friend). A pure synergy of visual tools tells the compelling story of sophistication and artistic achievement so often assigned to jazz. "In my work I try to make things as simple as possible," says Slavimir Stojanović. "Jazz music is very complex. And that was a challenge—how to make a poster simple but strong considering the very complex content. I used the trumpet as a visual symbol that everyone connects to jazz. Simple. But when you make it out of ordinary matches, electric wire or a light bulb, then it finds its complexity.

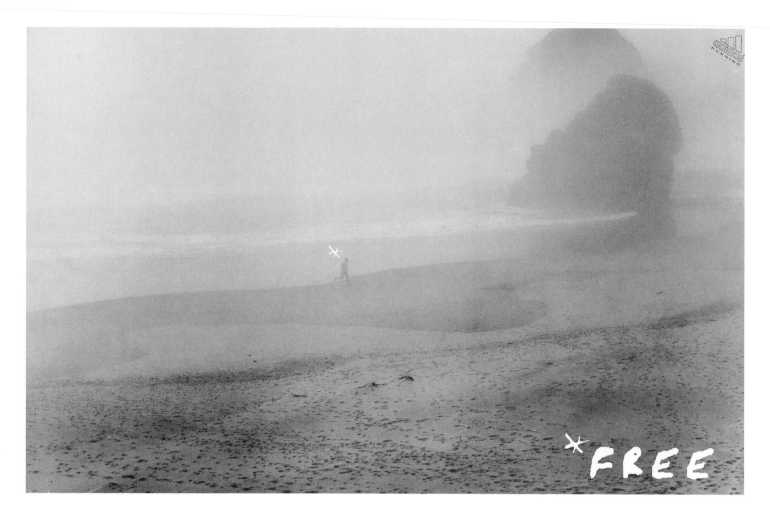

FREE

AGENCY: Leagas Delaney London, 1997
COPYWRITER: Sean Doyle
ART DIRECTOR: Dave Dye
PHOTOGRAPHER: Sally Gall
CLIENT: Adidas

It is fair to say that this particular ad, together with the other two from the same print campaign—and supported with excellent TV work as well—is responsible for turning Adidas' stumbling commercial fortune around. When it first appeared, it was so sophisticated for the sneakers market that even dedicated Nike ad followers had trouble figuring it out. Atmospheric and, unusually for sports gear, not brightly coloured, it tells a story of a personal aspect of sport—the freedom that running can bring. It's almost philosophical in expression, producing a dialogue with the viewer and the brand at the same time.

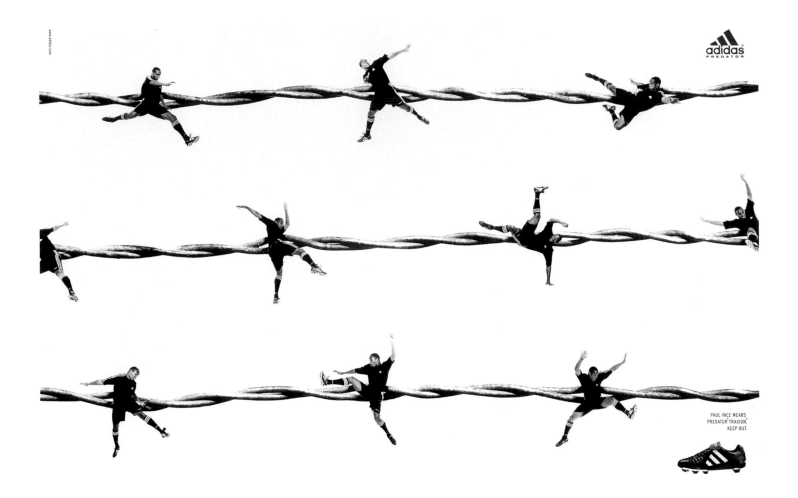

PAUL INCE WEARS.
PREDATOR TRAXION.
KEEP OUT.

27 INCE WIRE

AGENCY: Leagas Delaney London, 1999
COPYWRITER: Kim Papworth
ART DIRECTOR: Tony Davidson
PHOTOGRAPHER: Nick Georghiou
CLIENT: Adidas

If you're not familiar with English football, Paul Ince is the captain of Middlesborough football club and an Adidas endorser. Just to show that both the client and the agency have joined the league of long-running excellent campaigns (*a la* Nike or VW), this poster is a wonderful metaphor tying together the strong points of Ince's skills and the product's features. Dramatic and intelligent, this is brand advertising at its best.

Fiery Fries. **BURGER KING**

FIERY FRIES

AGENCY: Saatchi & Saatchi Singapore, 1998
COPYWRITER: Andrew Clarke
ART DIRECTOR: Andrew Clarke
DIGITAL IMAGING: Procolor
CLIENT: Burger King

One can't help but get a sense of Dali when looking at this ad. A juxtaposition of the two most obvious elements of every burger experience—fries and ketchup—executed in a way that is literally eye-opening. The similarity with a real match-stick is almost frightening. This ad represents a visual pun, characteristic of so many ads in the no-copy movement, but here it is presented with a depth and intelligence that silences those who claim no-copy is actually sheer creative laziness. People love unexpected twists of reality. "I think it's important to always be on the look out for inspiration and it was certainly true in the case of this poster. While I was working on the ad I was sitting in a pub one lunch time close to the office (I'd like to say I was sitting in a Burger King, but I wasn't). On the menu was Thai Spicy Fries similar to the ones Burger King were looking to promote. Of course I ordered them, simply wondering what they tasted like. I dipped one in some ketchup and immediately noticed it resembled a match. A gift? Luck? I could have missed it. The chip is a model about 10 inches long. It was all shot in-camera except the tiny curl on the ketchup at the end. That was re-touched in." Andrew Clarke

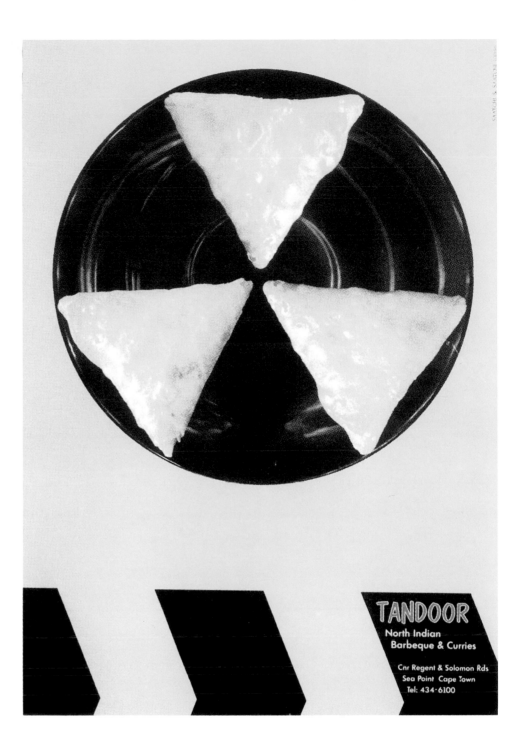

TANDOOR HAZARD

AGENCY: Saatchi & Saatchi Cape Town, 1999
COPYWRITER: Mark Mason
ART DIRECTOR: Mark Mason
DIGITAL IMAGING: Procolor
CLIENT: Tandoor North Barbeque & Curries

Again, a truly wonderful play on visuals and their associations! Very similar in thinking to the previous ad, but a bit more radical. Three samosas arranged in the shape of a radioactive sign, surrounded by a strong yellow colour, reminiscent not only of a real radioactive warning, but of the colour of a strong curry. Whoever has tried some of the spiciest of Indian cuisine will not only understand this ad, but will feel their mouth burn again! This is actually where this ad will work best: a hilarious joke for true connoisseurs. For those uninitiated it is maybe a bit puzzling. Which is not bad for advertising. The visual is so strong and iconic that it almost could be used as an international logo for Indian food. Particularly its most potent examples.

STEINLAGER

AGENCY: Saatchi & Saatchi New Zealand, 1999
COPYWRITER: Damon O'Leary
ART DIRECTOR: Basil Christensen
CLIENT: Lion Breweries

"While Steinlager is an incredibly popular beer with a sharp taste," reveals the creative team, "it also has a reputation of having a bit of a bite the morning after. The campaign celebrates both these attributes with an underlying theme that suggests that with pleasure sometimes comes a little pain." Hence the merger of sexy images and a pinch made with a bottle top. The campaign is a good example of how stylish beer campaigns have become, exploring even the tiniest of the product's characteristics in a market driven purely by image. In this case it is done boldly and strikingly, imprinting itself on the viewer's mind.

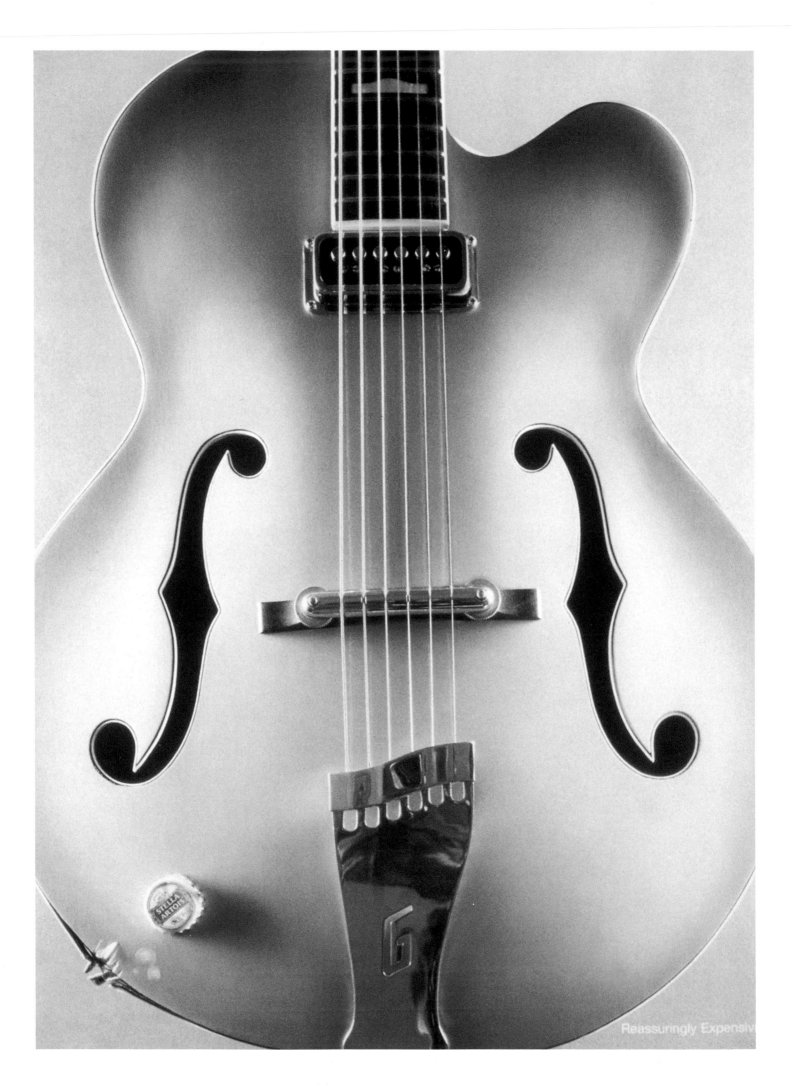

Reassuringly Expensive

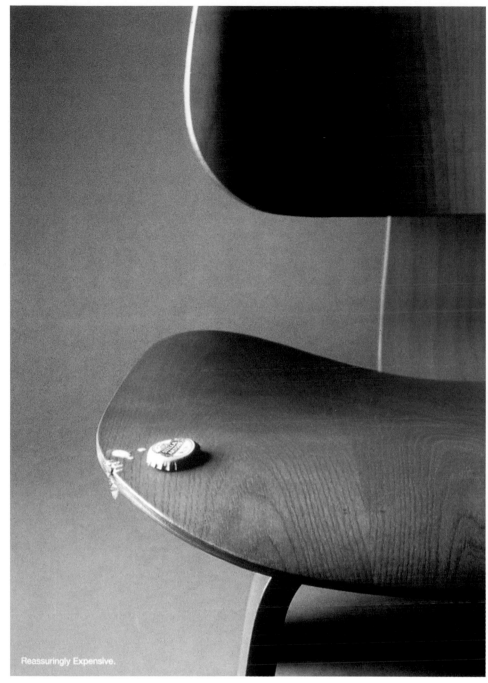

Reassuringly Expensive.

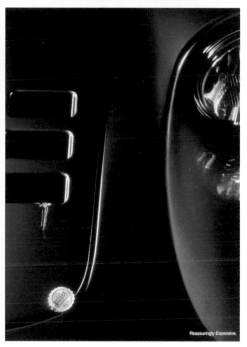

STELLA ARTOIS CAMPAIGN

From time to time, a campaign comes along that reminds us of all the legendary moments in advertising history—all those breakthroughs that have become milestones in the development of the trade. Stella Artois is already famous for its slick and brilliant "French" TV ads (with copy, unfortunately!). A lot of brain power is evident there. It's the same with this print campaign. No product shot, and yet, everyone is talking about it; no copy, and yet, you can write a novel based on the meanings conveyed in each picture; no company logo in the bottom right corner, and yet, it is superb branding. Playing on the product's positioning—as expensive, but worth it—this campaign is an extreme presentation of the underlying idea executed successfully. All the products featured act as ridiculously expensive bottle-openers for Stella—one of the most stylish sets ever designed to support a bottle of beer.

AGENCY: Lowe Lintas London, 2000
COPYWRITERS: Mick Mahoney, Andy Amadeo
ART DIRECTORS: Mick Mahoney, Andy Amadeo
PHOTOGRAPHER: Jenny van Sommers
CLIENT: Whitbread Beer Company

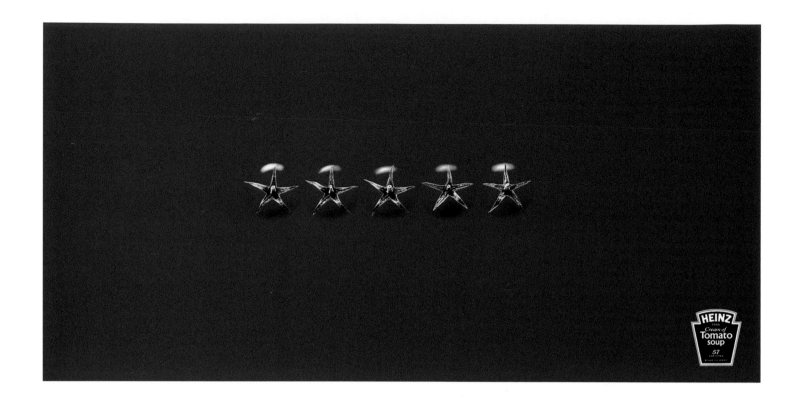

5-STAR

AGENCY: Leo Burnett London, 2000
CREATIVE TEAM: Paul Miles & Adam Staples
PHOTOGRAPHER: Jonathan Knowles
CLIENT: Heinz

It is an old advertising adage that ideas are all around us and that all we have to do when creating an ad is to look in the right way at ordinary things. This ad magnificently does just this. So here, stalks become stars. There is even clever political symbolism here, linking tomato soup with the insignia of a military rank (like the five stars of a general rank) and a bit of China-like communism thanks to a blood-red background (and, again, stars). Who can question that one picture is not worth a thousand words? The creative team responsible for this campaign has an elaborate philosophy behind the ad: "Involve the viewer more in an advertisement and you are halfway there. It's much more satisfying not forcing a piece of communication down someone's throat and letting them take something out of it for themselves. The 'Oh, that's clever' approach. It's the same principle that can be applied to most forms of art. Secondly, why clutter something? The fewer elements the better. Communication should be as simple as possible. Some audiences are a lot more intelligent than we give them credit for. As for the ad, it seems so obvious now. To get there, though, you have to pick a ripe juicy tomato, look at it and say 'Ooh, the stalk looks like a star'. Look back at the product name and you have 'Cream of Tomato Soup'. Place five tomatoes in a row and you have '5-star', which gets you to 'Cream of'. Throw on a red background to add intensity to the stalks and at the same time brand the ad. Finally the logo. Not even a packshot."

CHEESE & GRATER
MATCH & BOMB

AGENCY: Ammirati Puris Lintas London, 1999
COPYWRITER: Jason Bolton
ART DIRECTOR: Per Kvalvaag
PHOTOGRAPHER: Charlie Dickens
CLIENT: Van Den Bergh Foods

For those not British, Flora is a principal sponsor of the London marathon, one of the biggest gatherings of its kind in the world. But it's one of the biggest carnivals and street parties as well. Hundreds of runners, helping to raise money for numerous charities come to the race dressed in all sorts of unbelievable costumes. Hence these two executions of this poster campaign featured on the sides of London's double-decker red buses. The ads capture the gist of the event in a very positive and memorable manner, reminding everyone to put the date in their diaries.

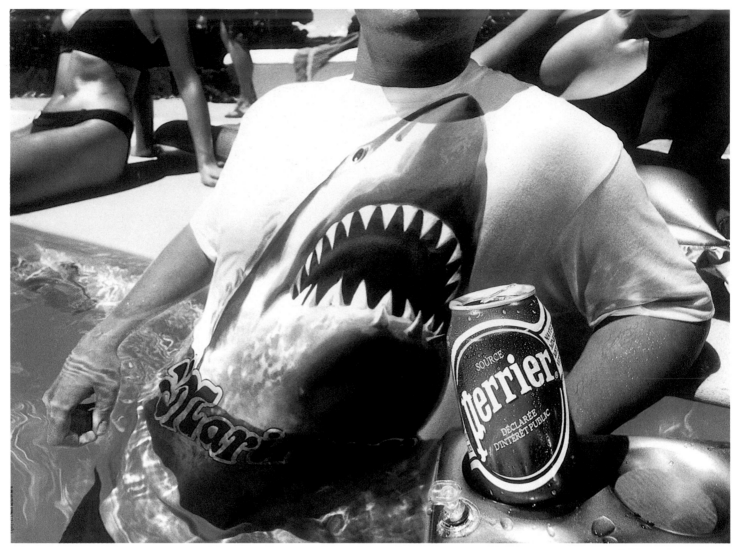

PERRIER

AGENCY: Ogilvy & Mather Paris, 1999
COPYWRITER: Thierry Chiumino
ART DIRECTOR: Laurence Nahmias
PHOTOGRAPHER: Vincent Dixon
CLIENT: Perrier

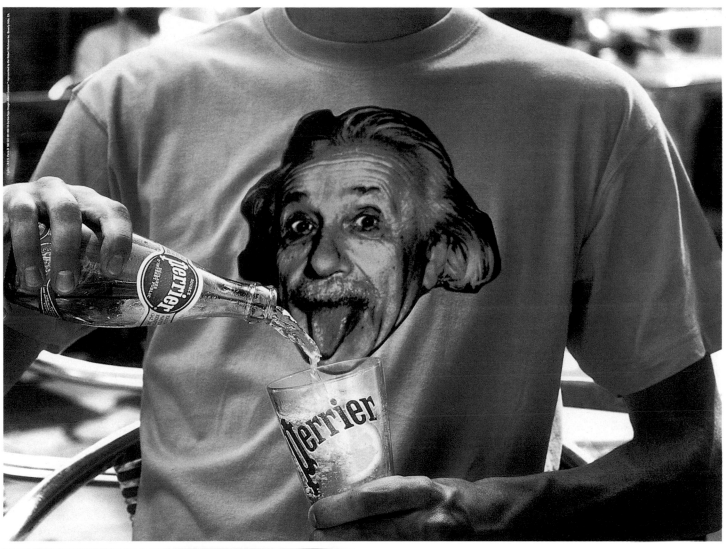

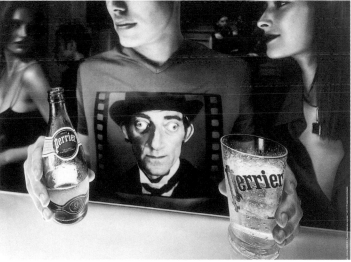

I believe this campaign could never have been shown during the winter. In this off-the-wall idea the iconic characters are used as a visual pun to support the refreshing power of Perrier water. Everyone is loose, quirky, laid back and, above all, thirsty. This is a school of refreshingly surreal visual ad jokes, which, if delivered well, build brand like crazy. In O&M creative team's own words: "O&M are handling a poster campaign for Perrier for the summer of '99. In the summer, when it's hot and sunny, we wear a t-shirt. Four posters portray a t-shirt with a well-known and recognisable character, often funny and always out of step: Einstein, a karateka (man doing karate), a first aider or even Uncle Sam. The product is present in the visual concept, and the posters in turn express thirst, desire, need or the fact that you cannot resist the product. Strong visuals which speak for themselves, so much so that the posters have neither a logo, nor a pack shot of the product."

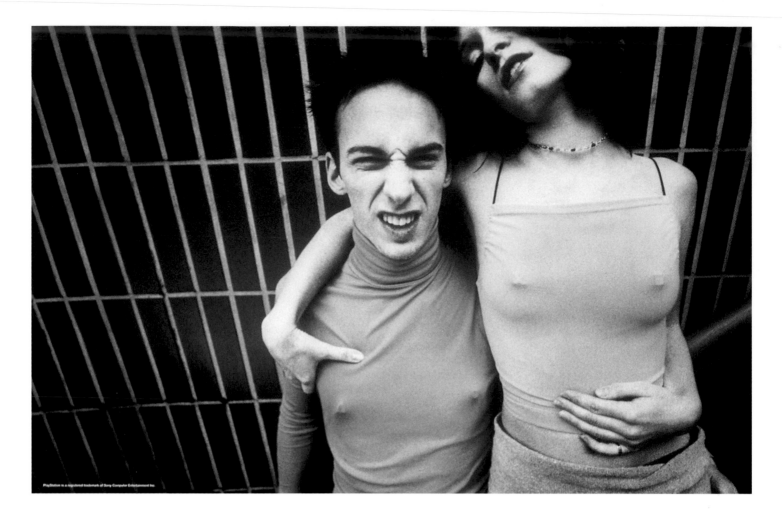

PlayStation is a registered trademark of Sony Computer Entertainment Inc.

NIPPLES

AGENCY: TBWA GGT Simons Palmer London, 1999
COPYWRITERS: Paula Jackson, Nick Hine
ART DIRECTORS: Nick Hine, Paula Jackson, John Anderson, Michael Burke
PHOTOGRAPHER: Mark Gaskin
CLIENT: Sony/Playstation

As the ad that started a highly acclaimed print and poster campaign, "Nipples" is a gold mine for semiotics students. Layers and layers of meaning, all in one picture, visually focusing on four small points in a grid. We have excitement, we have dedication, we have a lifestyle, we have belonging and community. We have power, we have sex and a lot of "cool". Most importantly, we have anthropomophisation of technology. Creatives said: "PlayStation's Shapes are a larger than life force—mysterious, enigmatic yet highly charged and magnetic—so you never quite know what exactly they are or where they will strike next." So, four pictograms that became a larger than life force, like runes in some strange, new sort of magic. It could happen only in a no-copy land. World, actually.

IN THE BLOOD

AGENCY: TBWA GGT Simons Palmer London, 1999
COPYWRITER: Trevor Beattie
ART DIRECTOR: Graham Fink
PHOTOGRAPHER: Graham Fink
CLIENT: Sony/Playstation

If "Nipples" started the story of technology anthropomorphisation, this ad pushed it further. It's not on the surface anymore, it's in the blood. The final dedication to a product. It is rare to see such a powerful dramatisation of a consumer's bond to a brand. Even a bit scary, though, especially knowing how many kids relate to their Playstation in real life. A totally immersing experience. Utterly masterful art direction gives this ad some sort of a bizarre documentary-like quality, sort of "as if..." aura. Finally, not even a company or a product logo is present here, stripping the ad (the whole campaign, in fact) of all traditional branding elements. Your grandmother might not understand it, but your kids will.

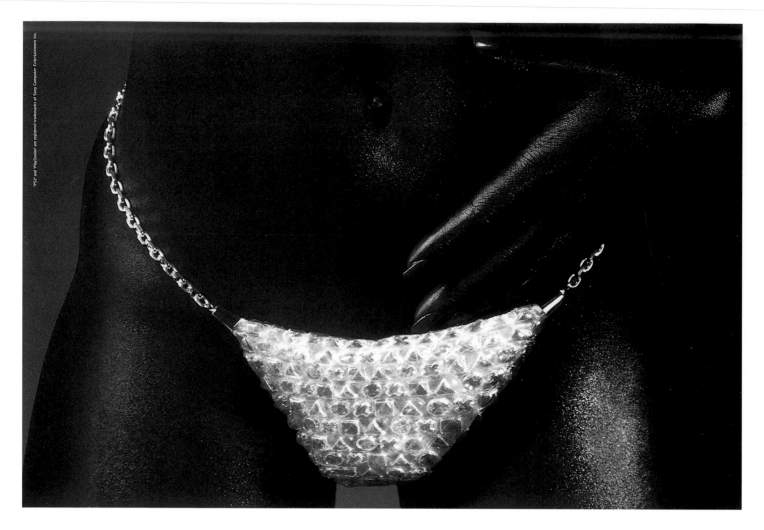

40 KNICKERS

AGENCY: TBWA GGT Simons Palmer London, 2000
COPYWRITERS: Paula Jackson and Nick Hine
ART DIRECTORS: Paula Jackson and Nick Hine
PHOTOGRAPHER: Cathy Haussan
CLIENT: Sony/Playstation

Visually maybe the most striking of all three, at least on the surface, this ad continues the story of Playstation's symbols in more explicit territory. This is a curious proposition: is it that the girls have the same passion for Playstation as the guys, or is this some kind of a more saucy promise for boys? And why are the knickers made of a package-protective material? And what does it mean that bubbles are replaced with familiar symbols? Well, you'll get no help from the people who came up with it: "There is no branding on the ad except a very small legal line," explain Paula Jackson and Nick Hine. "This is to ensure the ad, whilst a striking and impactful shot, is subtle and the audience have to work hard to 'get it'." I'm sure this will become a very popular poster for kids' bedrooms.

Title: GEAR SHIFT

ARTIST: Romulus Rost
FORMAT: Audi TT Coupe
MEDIUM: Aluminium, rubber, steel

AUDI AMERICA

AGENCY: McKinney & Silver Raleigh, 2000
COPYWRITER: Christopher Wilson
ART DIRECTOR: Ralph Watson
PHOTOGRAPHER: Tony Pearce
CLIENT: Audi America

New Audi designs are lauded all over the world for their sophistication and they signify a whole new approach to how we view a car. Not just a utility machine, not just a status symbol, but a moving work of art, deliberately designed from the outset to be like that. Audi TT was awarded the D&AD pencil for its design—a rare treat for any industrial designer. The idea of it being a work of art was also the strategy behind this slick print/poster campaign that reflects very precisely the product characteristics. The creative team puts it succinctly: "The Audi TT is a work of art in every detail. How better to communicate this than by abstracting different parts of the car and displaying them complete with artist's credits." By "artist", the agency means Romulus Rost, Audi TT designer.

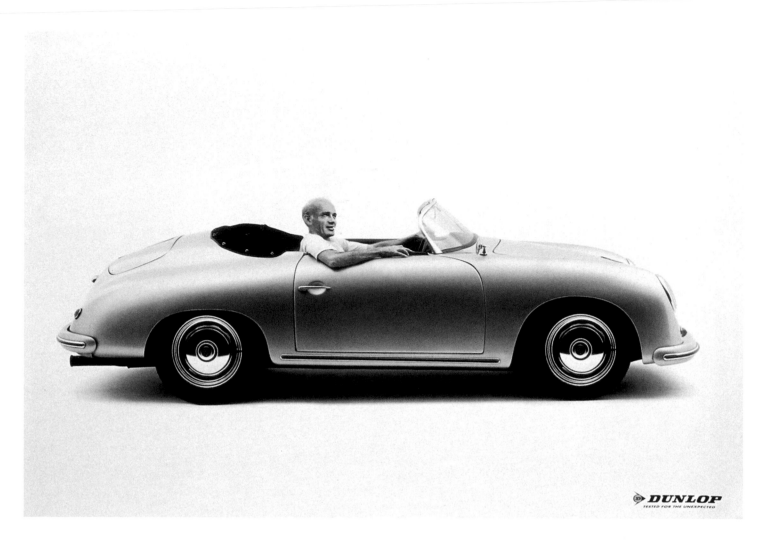

JAMES DEAN

AGENCY: TBWA Hunt Lascaris Johannesburg, 2000
COPYWRITER: Erik Vervroegen
ART DIRECTOR: Rory Carter
ILLUSTRATOR: Neil Webb
CLIENT: Dunlop

There is a sub-genre of sci-fi called the "alternative history", usually dealing with what would have happened if... (for example, "what if the Nazis had won the Second World War?", or "what if President Kennedy hadn't been shot?"). It is, therefore, quite refreshing to see the same principle applied in a branding exercise. One of the most dramatic moments in modern mythology conveyed the necessary power to produce an emotional engagement. Note the authentically relaxed elbow resting on the edge of the doors of a stylish convertible. "In creating this ad I was trying to think of an image which instantly conveyed the message that Dunlop tyres can save lives. The safety aspect of tyres has been conveyed too many times by ads which showed tyres 'sticking' to the road. I wanted to show the biggest ultimate benefit of road holding which is: living longer. I thought of all the people who would probably have lived to old age if they hadn't died in car accidents. The person shown in the ad would have to be someone famous, someone who everyone knew died young in a motor accident. I chose Hollywood icon James Dean. That was the easy part. The difficult part was 'aging' his face, making him look old, yet still recognisable as the movie star who died decades ago. The sight of a 70-year-old James Dean behind the wheel of a sports car fitted with Dunlop tyres says more about safe driving than any amount of copy." Erik Vervroegen

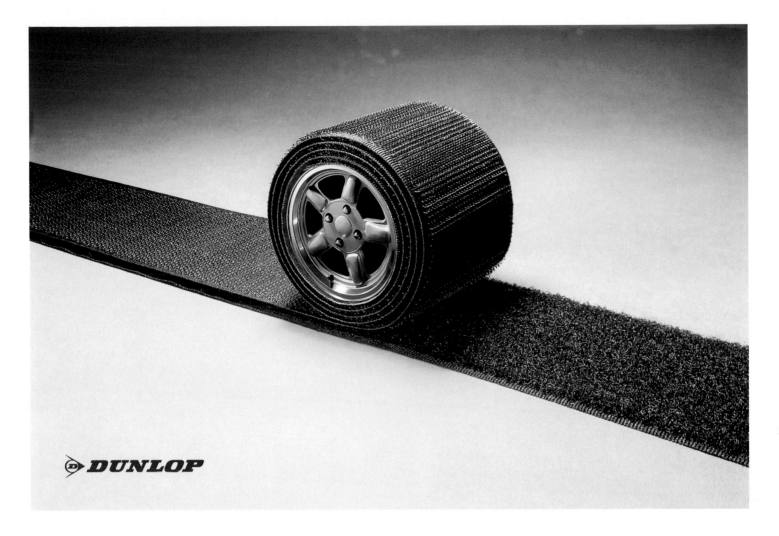

43

VELCRO TAPE

AGENCY: Doris Soh & Associates Singapore, 1999
COPYWRITER: Allan Tay
ART DIRECTOR: Joseph Tay
PHOTOGRAPHER: Teo Studio
CLIENT: Dunlop

"Dramatise the feature/benefit"—this is a phrase residing in every adman's standard bag of tricks. Various ideas have been played around with over the years on the attribute of good grip for automobile tyres. From orangutans to steel marbles, the repertoire was truly exhausting. But nobody, until this ad, has played with the association with one of the most ubiquitous garment accessories in the world: Velcro tape. It is so obvious and yet it was missed until this ad. "Velcro is a visual expression of communicating good grip, hence safety over performance, for Dunlop tyres. Although it has no copy, we believe it delivers more in the sense that it quietly and confidently positions Dunlop as an intelligent brand. In fact, a subliminal persona is created by engaging our audience in our visual pun." The same client as on the previous page, but a totally different approach. You can almost hear that tearing sound coming out of the picture!

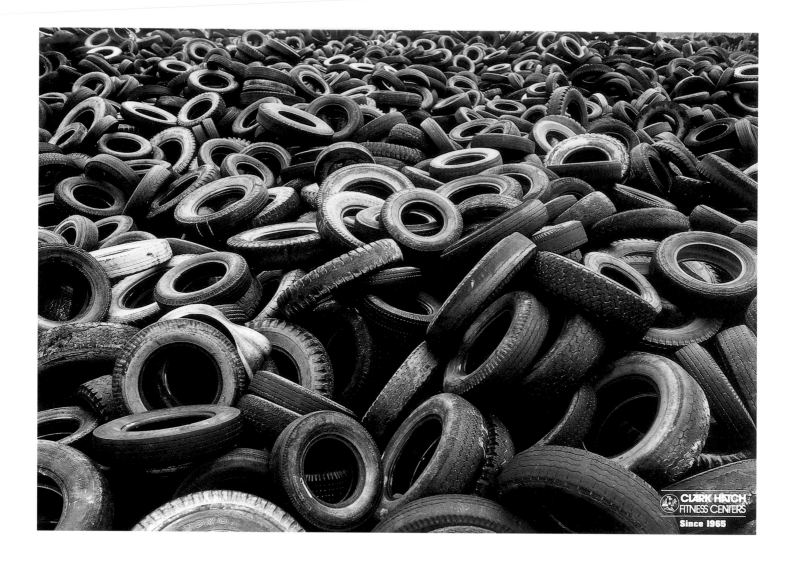

SPARE TYRES

AGENCY: INK Singapore, 1999
COPYWRITER: Troy Lim
ART DIRECTORS: Low Eng Hong and Ng Tian It
CLIENT: Clark Hatch Fitness Centres

This ad demands particular effort on the part of the viewer to decipher it—a sort of mental gymnastics that connects the beginning and end of the idea. Or, in this case, the picture and its true meaning. However, sometimes you have to be blessed by a right sort of a client, as is obvious from Troy Lim's story: "With dozens of new fitness centres sprouting up on every corner, Clark Hatch needed to remind everyone that they were the true fitness experts because they'd been around for longer. This is essentially how the first meeting went: 'We need to mention the thousands of satisfied customers who've had dramatic weight-loss and a better physique after training with us', they said. 'Sure', we said. 'And we should emphasise that Clark Hatch has been doing this for more than 30 years' now.' 'Sure.' 'One more thing—our customers don't like reading long copy. Do you think we could keep the copy really short?' We smiled."

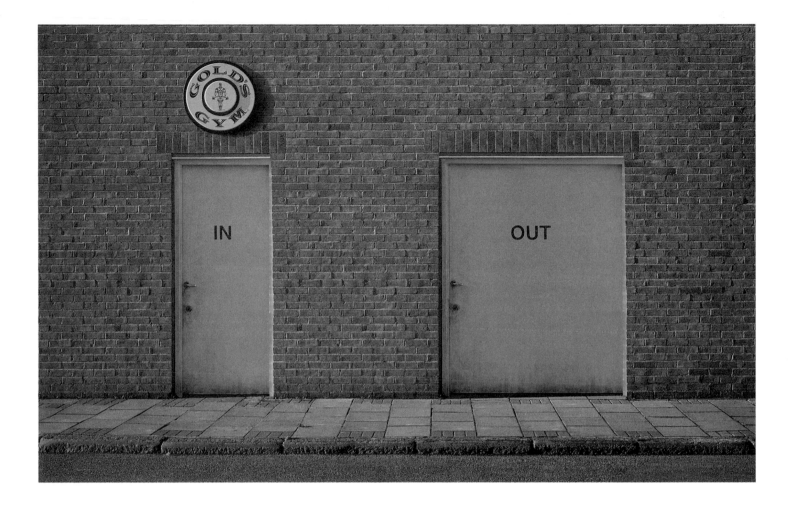

IN / OUT

AGENCY: JACK
COPYWRITER: Brian Millar
ART DIRECTOR: Marcus Fernandez
PHOTOGRAPHER: Allan McPhail
CLIENT: Gold's Gym International

Brian Millar explains the principle behind this ad: "Today nobody has time to read anything they don't want to. The process of making ads has become one of subtraction, taking anything out of the ad that gets in the way of the idea. In other words...on the page, in your head, bang." Jack Fund, a creative director on the ad, sheds some more light on it and reveals a very interesting story on targeting the ad to male and female audiences: "This ad pares Gold's Gym down to its bare essence. One simple photograph captures the heritage of the brand that started the whole fitness revolution and at the same time plants a seed that Gold's is a place where people don't take themselves too seriously. The neat thing about this ad is how versatile it is. While men typically want to bulk up, women want to slim down. For publications aimed at the female audience, the doors were flipped to emphasise weight loss."

a b c d e f g h i j k l m n o p q r s t u v w x y z [©]

ALPHABET

AGENCY: Mustoe Merriman Herring Levy London, 1999
COPYWRITER: Simon Hipwell
ART DIRECTOR: Dean Hunt
CLIENT: Penguin Books

Now, is this a copy or a no-copy ad? Here letters are not "letters" in the traditional sense with a certain meaning attached to them. It is the alphabet, a picture of the alphabet, and the letters are used as a graphic illustration of the idea. "The inspiration behind this ad is that no matter how compelling, moving or controversial books may be, they are all made up from just 26 letters," explain Simon Hipwell and Dean Hunt. "To copyright these 26 letters was to take a position above all other publishers—to own language. Something that could only be done by Penguin Books."

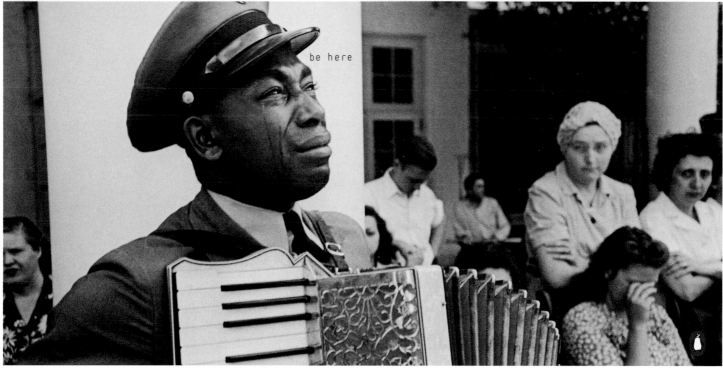

BE HERE

AGENCY: Mustoe Merriman Herring Levy London, 2000
COPYWRITER: Simon Hipwell
ART DIRECTOR: Dean Hunt
PHOTOGRAPHERS: Ian and Peter Davies at Patricia
McMahon and Ed Clark
CLIENT: Penguin Books

Another clever idea from the same creative team as they explain here: "The idea behind the 'Be Here' campaign is to use emotive and impactful images to make an undeniable claim—that books remain the only true conduit to different worlds, different cultures and different emotional experiences. We chose images that might prompt the viewer to think: 'wow, what must it be like to be in that situation, that place, that person's mind?'."

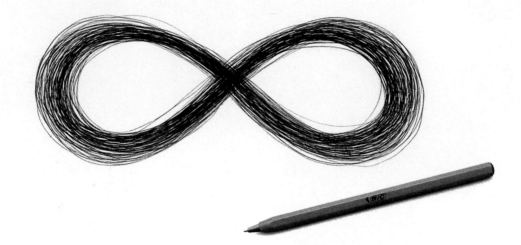

INFINITY

AGENCY: TBWA Hunt Lascaris Johannesburg, 2000
COPYWRITER: Clare McNally
ART DIRECTOR: Jan Jacobs
PHOTOGRAPHER: David Prior
ILLUSTRATOR: Jan Jacobs
CLIENT: BIC

Sometimes the simplest route to a powerful idea is not to have an idea at all. Just show the product's feature. Clare McNally's explains how the end result was arrived at: "Mmm... I was asked to write some copy for our ad that has no copy for a book written about ads with no copy. Confusing, but I'll try anyway. We had to show that a BIC pen writes for a long time. Infinitely in fact. So we drew the infinity symbol with a BIC pen. Um... that's it."

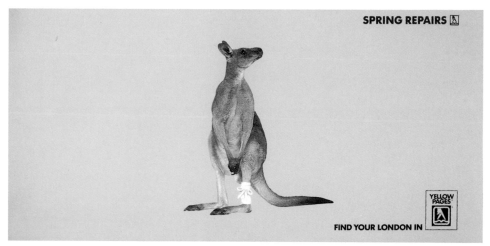

SPRING REPAIRS

FIND YOUR LONDON IN

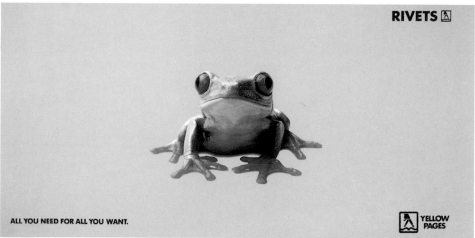

RIVETS

ALL YOU NEED FOR ALL YOU WANT.

YELLOW PAGES

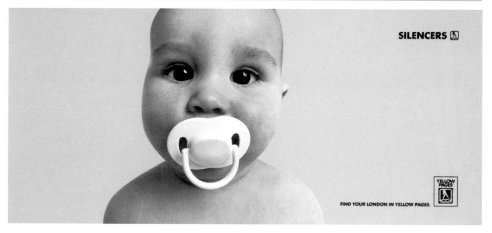

SILENCERS

FIND YOUR LONDON IN YELLOW PAGES.

YELLOW PAGES CAMPAIGN

AGENCY: AMV BBDO London, 1997
COPYWRITER: Diane Leaver
ART DIRECTOR: Simon Rice
CLIENT: Yellow Pages

"Words cannot describe what we went through to come up with this campaign," said Diane Leaver and Simon Rice when I asked them for a comment. Weird. As is the campaign. Bold, quirky and noticeable. It is still one of the most striking campaigns for one of the most boring—but useful—services in the world. The best thing here is that there are so many topics in the directory to play with that it is unlikely creatives will ever run out of ideas!

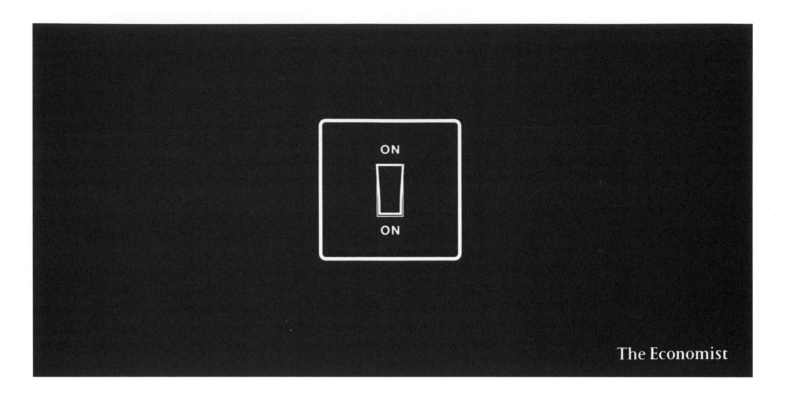

ALWAYS ON

AGENCY: AMV BBDO London, 1999
COPYWRITER: Jane Rajeck
ART DIRECTOR: Mel Rumble
CLIENT: The Economist

"I'll admit that my partner and I were worried when our first live brief landed on our desk. Not just because the brief was for The Economist but because we had just left college and were on the first day of a placement in arguably one of the best advertising agencies in London. However, we were told to 'have a go' and not to be too disheartened if nothing got through. After all, the majority of The Economist ads never get through. So we 'had a go'. Before we even looked at the brief we agreed that any ideas we came up with had to be clever. Because both The Economist ads and The Economist readers are clever. But we also agreed that it was perhaps equally important for our ideas to be relevant. Due to the clarity of the brief and its proposition, we had a solid and believable reference for what we were trying to say. There were just so many ways to say it and some could be said more cleverly than others. Although we didn't consciously set out to do an ad with no copy, we were fully aware that in this case, spoon feeding the message was not appropriate to the brand or to the target audience. Perhaps that's why once we'd nailed the core message the execution seemed to sort itself out. When I was asked what the inspiration for this ad was I found it difficult to answer. I don't know what inspired us to do this ad. I find it impossible to deconstruct my own thought process, yet easy to deconstruct a finished ad done by others. This, I think, is because advertising is unique in the way that doing it well requires two parts of your brain, the conscious and the subconscious. Good ads are rare, but you know you've done one when after trawling through the logic, there's a kind of free-fall in your brain. A moment when logic and something else fuse." Jane Rajeck

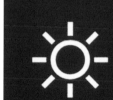

BRIGHTNESS

AGENCY: AMV BBDO London, 1998
COPYWRITER: Oliver Devaris
ART DIRECTOR: Damon Collins
CLIENT: The Economist

The interesting thing is that The Economist campaign reached its cult status almost exclusively based on ads full of great copy. However, from time to time, an ad comes along which percolates that same magic contained in words and presents it visually. Like "Always On", this ad is simple and striking, as all great ads should be. But it is slightly easier to decode, although both ads in effect are saying the same thing. In a way, these two ads go a step further in transforming what could be a full blown written statement into not even a picture, but a pictogram. Oliver Devaris and Damon Collins put it succinctly: "In a campaign traditionally built around pithy headlines, the challenge was to say everything by saying nothing. How else can you say 'read The Economist and become as bright as you possibly could be' in less than one word?" Here's how.

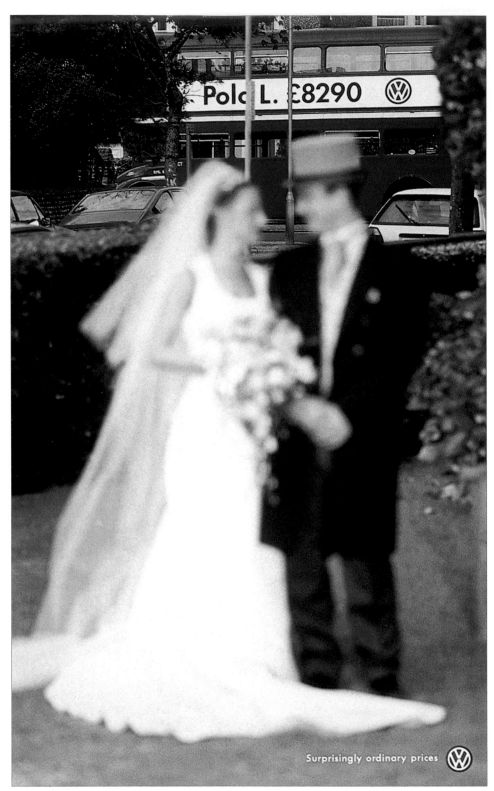

Surprisingly ordinary prices

WEDDING

AGENCY: BMP DDB London, 1999
COPYWRITER: Clive Pickering
ART DIRECTOR: Neil Dawson
PHOTOGRAPHER: Paul Reas
CLIENT: Volkswagen

If you were to try to find the best example of the old advertising truth that to have a great and groundbreaking ad you need not just a great ad agency, but a great client as well, then work being produced for Volkswagen over the past decades is such an example. Initiated by Bill Bernbach himself, a stream of powerful work continues to be produced to this day. During the last few years London's campaign, based on surprisingly good value-for-money VW cars, has won almost all of the world's most prestigious awards. The above ad is a wonderful example from the campaign: very subtle, funny, product-focused and powerful. Basically, this is a hard-sale approach, having price as a strategy. However, hard-sale advertising probably never ever got so sophisticated as here.

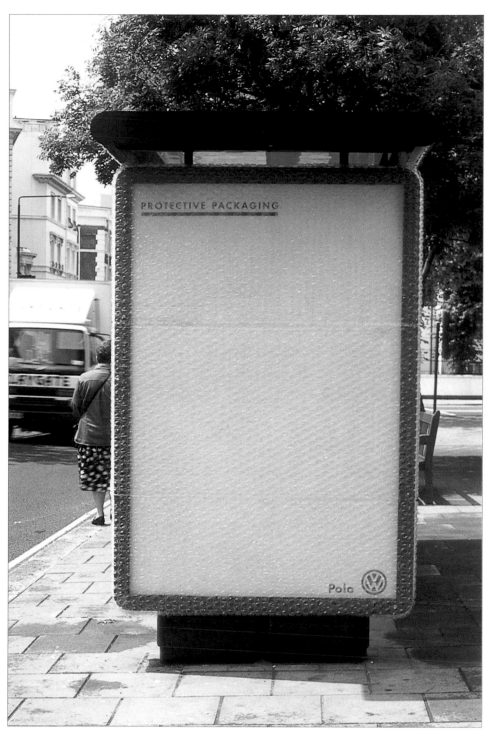

PROTECTIVE PACKAGING

AGENCY: BMP DDB London, 1999
COPYWRITER: Ed Edwards
ART DIRECTOR: Dave Masterman
CLIENT: Volkswagen

The brilliance of the campaign wasn't restricted to traditional media executions only. The agency pulled out some excellent ambient stunts as well. In this case, traditional bus shelter poster sites are used for introducing three-dimensional executions working on two levels: a traditional poster mounted within the window and then wrapped up in familiar protective bubble-wrap. This was a dramatic way to stress the product's safety features, supported by a strapline "Protective Packaging". The physical attribute of these posters brings to life the idea in a tremendous way, generating not just stronger impact for passers-by and people waiting at bus stops, but sparking some spin-off publicity as well. It was a simple, but strong example of quality street advertising theatre.

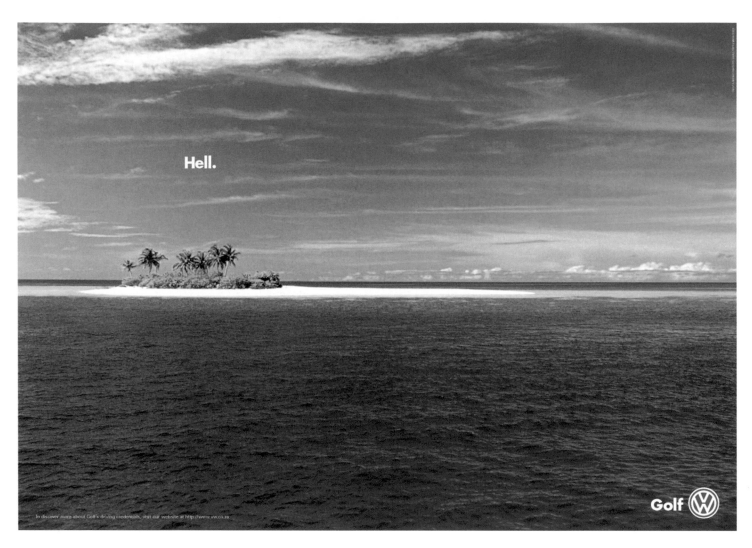

HELL

AGENCY: Ogilvy & Mather RS-T&M, 1998
COPYWRITER: Wayne Lubbe
ART DIRECTOR: Jonathan Lang
CLIENT: Volkswagen of South Africa

This ad is a lesson in optics: how to see something completely differently to the way most people would see it. And the bigger the difference between the stereotype and the new interpretation, the better. When you turn this principle into a branding device, results can be incredible. "If a small desert island with white sand beaches and a palm-tree oasis, in the middle of the wide blue ocean sounds like paradise to you, you're obviously not a Golf driver," said creatives. "The Golf brand is about roads and the freedom of the road. It's about driveability. Challenge. And the chance to grip the corners and hug the curves. This ad emphasises this point by demonstrating that life would be hell where there are no roads or the opportunity to drive your Golf. Through the Golf driver's eyes."

Natural Player.

SERGIO TACCHINI
WINTER LAB

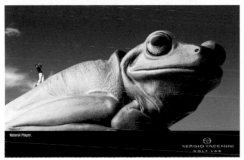

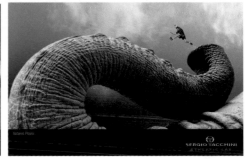

NATURAL PLAYER

AGENCY: Armando Testa Milan, 2000
COPYWRITER: Maurizio Sala
ART DIRECTOR: Michele Mariani
PHOTOGRAPHERS: Mark Laita and Carlo Miari Fulcis
CLIENT: Sandys/Sergio Tacchini

The slightly surreal feel to this campaign was derived from the client's philosophy: "Our creative concept was born from Sergio Tacchini's attitude to sport," points out Michele Mariani. "A 'natural' attitude, not exaggerated, not aimed at crushing the opponent, but simply born from a personal pleasure to play sport. These sports are all presented in surrealistic places, only linked to reality through the colours. It gives you the feeling of elegant and refined sportswear."

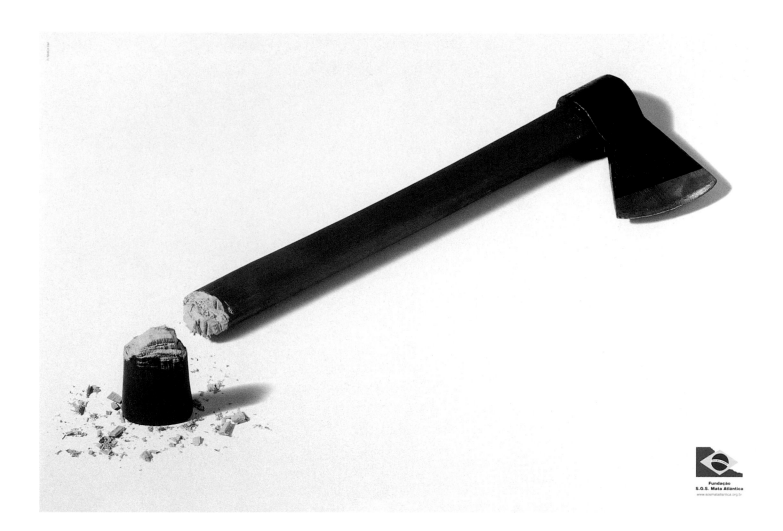

56 S.O.S.

AGENCY: F/Nazca S&S Sao Paulo, 1999
COPYWRITERS: Wilson Mateos
ART DIRECTORS: Marco Aurelio Monteiro
PHOTOGRAPHER: Rodrigo Ribeiro
CLIENT: Foundation S.O.S. Mata Atlantica

"A human being is a fascinating creature"—is the deep conviction of the creative team from F/Nazca. "He's not satisfied with just being part of nature, but he also decided to change it. He also isn't satisfied in changing it, he has to destroy it too. It wasn't enough to destroy it, he used nature itself to do it." This ad demonstrates a technique sometimes referred to as a "boomerang effect", where the object of the ad is treated in the same way it itself is meant to affect other objects.

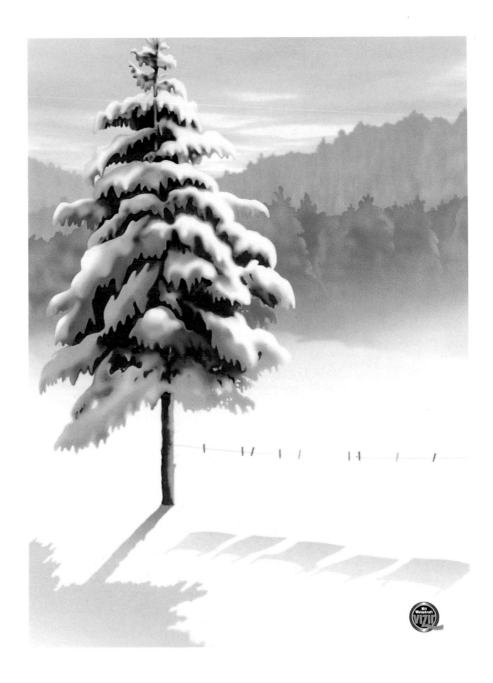

LANDSCAPE

AGENCY: Leo Burnett Warsaw, 1999
COPYWRITERS: Lech Krol, Ula Turska
and Renata Satanowska
ART DIRECTORS: Lech Krol, Martin Winther
and Alek Januszewski
ILLUSTRATOR: Jacek Surawski
CLIENT: Procter & Gamble

To show that something is literally "white as white" is not an easy task. However, if you compare two objects of roughly the same shade of white one will become almost invisible. So, why not turn this into an advantage for the product? Why not use just a shadow of an object to stress its whiteness? This is a way of finishing the thought applied in a clever way to benefit the brand. To support the "wintery" feel of the idea, art direction has played with illustrated Christmas-card types of approach. It makes the viewer feel the freshness and the cold of a clear winter day.

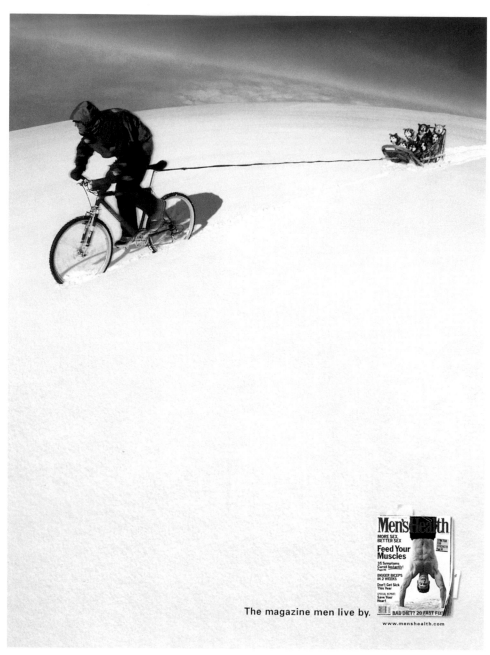

The magazine men live by.

DOG SLED

"We used the oldest ad trick in the book—exaggeration. The hard part was coming up with visuals that were surprising, and hopefully, witty." This was Sean Riley's explanation for the thinking behind the ad. Knowing the client and its magazine—whose mission is to increase the number of fit men on the planet—exaggeration was just the right approach. And the pill is even sweeter to swallow if it's rolled into a good joke. The picture conveys the product in a fun way with a hint of showing off—which most fit men have indulged in at one time or another.

AGENCY: The Martin Agency Richmond, 1998
COPYWRITERS: Joe Alexander, Christopher Gyorgy
ART DIRECTOR: Sean Riley
PHOTOGRAPHER: Per Breiehagen
STUDIO ARTIST: Mark Brye
CLIENT: Men's Health

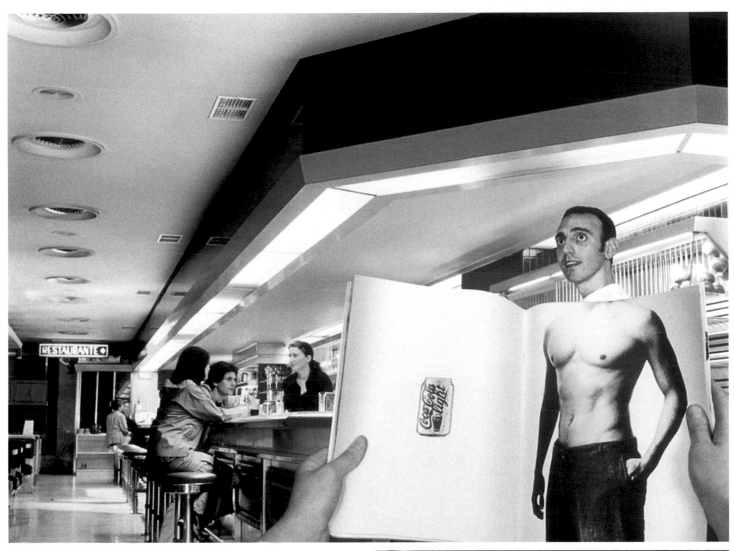

CAFETERIA
STATION

AGENCY: McCann-Erickson Madrid, 2000
COPYWRITER: Juan Nonzioli
ART DIRECTOR: Rebeca Diaz
PHOTOGRAPHER: Sara Zorraquino
CLIENT: Coca-Cola

Set in ordinary places like a station and a cafe, the campaign highlights what the brand is trying to say: we can all be slim if we are careful. Superimposing the heads of passers-by on to beautifully designed models' bodies on magazine spreads subtly suggests and persuades. A connection between ordinary and extraordinary; reality and dreams; people and products. Basically, everything that the soft drink manufacturers are telling us all the time. A play between two objects, within two perspective lines, and a combination of them in an almost animation-like style makes these ads fresh and intelligent. Again, the idea of deciphering the picture, of solving the semiotic puzzle, gives us the sense of a deeper meaning.

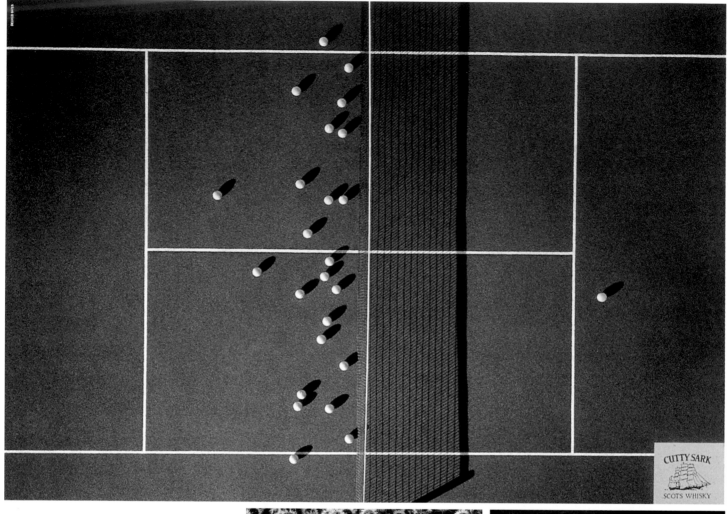

CUTTY SARK CAMPAIGN

AGENCY: Delvico Advertising Madrid, 1997
COPYWRITER: Nacho Santos
ART DIRECTOR: Angel Villalba
PHOTOGRAPHER: Sara Zorraquino
CLIENT: Importaciones y Exportaciones
Varma/Cutty Sark Whisky

"The objective and strategy of this campaign was to position the whisky as a different brand for people who do not follow rules and who are different from the rest," explains the creative team who developed the campaign. The result of this relatively simple task is one of the most stylish and visually soothing campaigns ever done for a whisky brand. Not only does it project the idea of being different by using quite obvious contrasts in colour elements, but it manages to radiate the calmness and that dim-light feeling that real whisky connoisseurs have when sitting in a quiet corner by an open fire with a glass in their hand. Also, quite astonishingly, the campaign manages to recreate the atmosphere of loneliness, or more precisely, individuality—this is not about drinking, but about lifestyle. Very subtle, but powerful branding. The idea of linking a colour to the object in each of the ads is also refreshing.

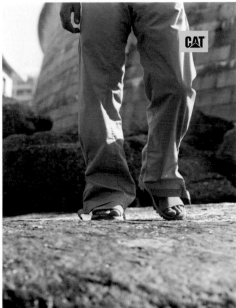

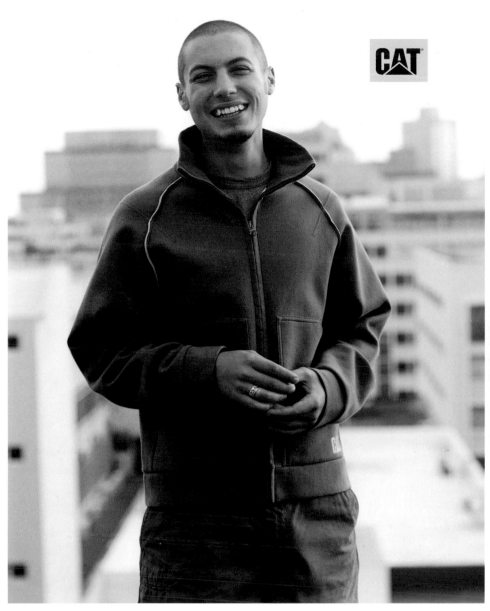

CAT

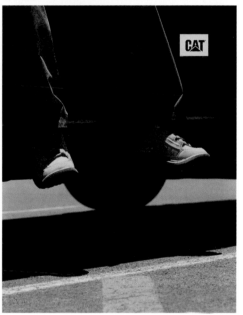

61 CAT

AGENCY: Magic Hat London, 2001
ART DIRECTOR: Rob Clarke
PHOTOGRAPHER: Paul Wetherell
STYLIST: Anna Cockburn
CLIENT: Caterpillar Workwear/Caterpillar Footwear

CAT is the largest manufacturer of earth moving equipment in the world and as such, the brand has had an indelible effect on our surroundings—as the company itself says: "empowering people to improve their lives". This spirit is continued in the development of CAT footwear and CAT workwear originally conceived to assist workers using CAT machinery in their work through the development of the now iconic honey-coloured CAT Colorado workboot. CAT campaigns were always prominent for their lack of complicated elements and reliance on simple images to project a connection with real life. This campaign follows the same formula as the authors describe here in more detail: "The campaign continues our tradition of featuring real people in environments without the gloss of fashion advertising campaigns. Creating the campaign was a wholly organic process. We selected Cape Town, South Africa as the location because of the architecture, which reflects that of any modern city—the environment where CAT footwear and workwear is used—and because of the ease of working there. With a basic plan of how we wanted to shoot products to represent their inspiration and functionality—work, urban or marine—we arrived in the city and jumped in a van, driving to the various areas of the city to look for inspirational locations. During location recces, with a firm idea of the type of person we wanted to represent CAT in our ads, we began to find people, not models, on the street, in shops and cafes. With all the basics in place the shots began to come together during discussions on the move, at lunch or dinner. The layout of the final executions, shown here, reflects the products advertised—clean, simple, authentic, and honest."

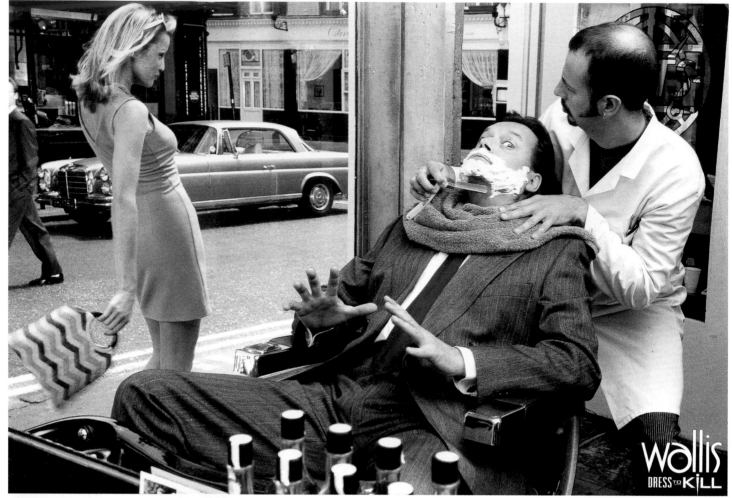

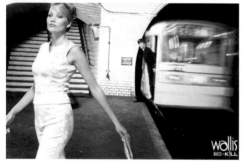
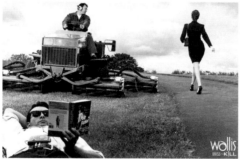
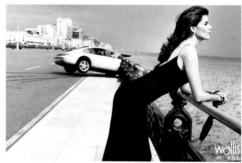

DRESSED TO KILL

AGENCY: Bartle Bogle Hegarty London, 1997
COPYWRITER: Victoria Fallon
ART DIRECTOR: Steve Hudson
PHOTOGRAPHER: Bob Carlos Clarke
www.bobcarlosclarke.com
TYPOGRAPHER: Andy Bird
CLIENT: Wallis Womenswear

This was the first ever brand building campaign for the UK womenswear retailer Wallis. The campaign, comprising four black-and-white press ads, was designed to get customers to re-evaluate the brand. Deliberately, the clothes are not the focus of the ads, although a broad seasonal range of evening, day and tailoring was chosen for the campaign. The photographs were shot in black and white to confirm Wallis' desire to concentrate on the brand, rather than display another season's trendy colourways. Due to the execution, black humour gives the brand wit, while sophisticated photography gives it style. This idea gave a well known phrase ("Dress to Kill") an extreme twist and the brand intelligence. A woman, unaware yet quietly assuming, gave the brand confidence. Bob Carlos Clarke, who is best known for his raunchy "on the edge" style of photographs of celebrities, shot the ads on location including a London Soho barbershop and a real metro station in Porte des Lilas, Paris.

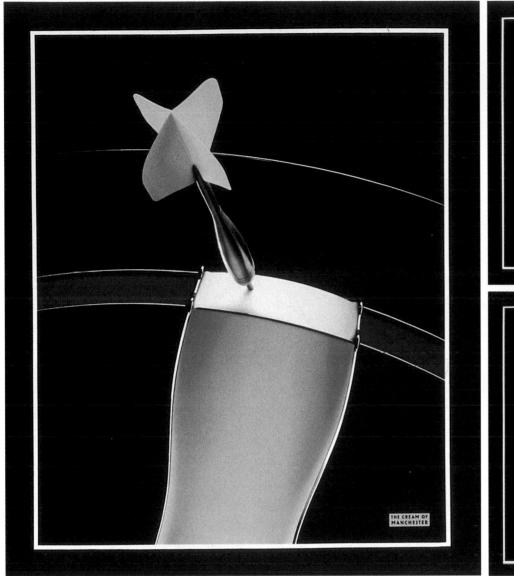

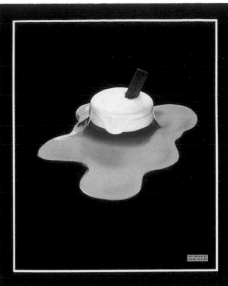

THE CREAM OF MANCHESTER

AGENCY: Bartle Bogle Hegarty London, 1996/1997
COPYWRITER: Jo Moore
ART DIRECTOR: Simon Robinson
PHOTOGRAPHER: David Gill
MODEL-MAKER: Gavin Lindsay
CLIENT: Whitbread Beer Company

Press work from the Boddingtons "Cream of Manchester" campaign is a strong example of no-copy advertising. The idea for the press campaign was to create poster sites in people's homes via the back cover of magazines. The creative idea for the campaign served to maximise this poster effect. Arresting visual imagery based on cream analogies replaced copy, and combined with the use of yellow and black, soon to be the signature colours for Boddingtons, became a powerful branding device. By 1997 the visual imagery had become so well recognised that the brand logo was removed—after research showed that over 75 per cent of respondents identified the advertising as Boddingtons. As stated in The Times at that time: "No-name advertising is a risky tactic, but when it works the impact is tremendous. Most companies can only dream of advertising recall levels of 80 per cent...very few brands and campaigns are strong enough to do this." The Boddingtons "Cream of Manchester" campaign was.

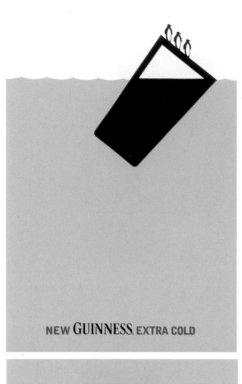

NEW **GUINNESS** EXTRA COLD

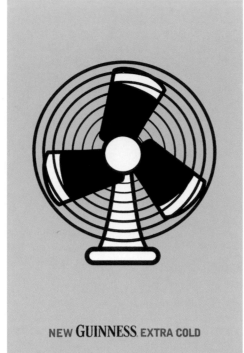

NEW **GUINNESS** EXTRA COLD

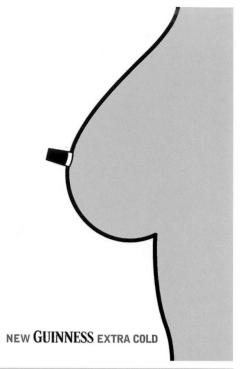

NEW **GUINNESS** EXTRA COLD

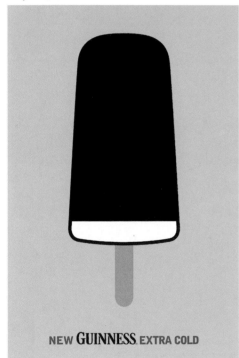

NEW **GUINNESS** EXTRA COLD

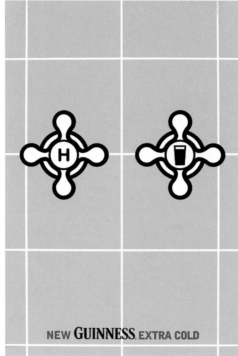

NEW **GUINNESS** EXTRA COLD

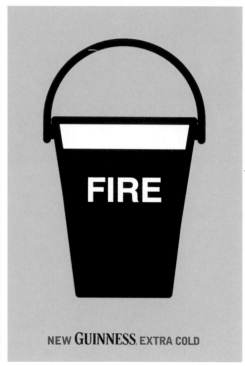

NEW **GUINNESS** EXTRA COLD

EXTRA COLD

AGENCY: AMV BBDO London, 1999
COPYWRITER: Jeremy Carr
ART DIRECTOR: Jeremy Carr
ILLUSTRATOR: Jon Rogers
CLIENT: Guinness

Beer, being a classic example of a "designer product", usually goes with all sorts of creative advertising. However, visual sophistication in beer print ads is not common. A black pint is a black pint and trying to present it as something else can be downright dangerous. Which is exactly why this campaign is so great. It is minimalist in visual language, but at the same time very stylish. It is funny and engaging, projecting the essence of the brand—refreshment, together with the physical attribute of being sold significantly colder than other brands—through a series of visual puns. They connect the characteristic black-and-white beer and head form within the shape of a pint glass with all sorts of different scenes, being cold or cooling something down being the underlying theme. However, the road to simplicity is sometimes hard, at least according to Jeremy Carr: "As I stared out of my office window, a beautiful girl walked by licking an ice lolly. A thought occurred to me: 'I wish she'd done that six months ago when I was trying to crack Extra Cold.' "

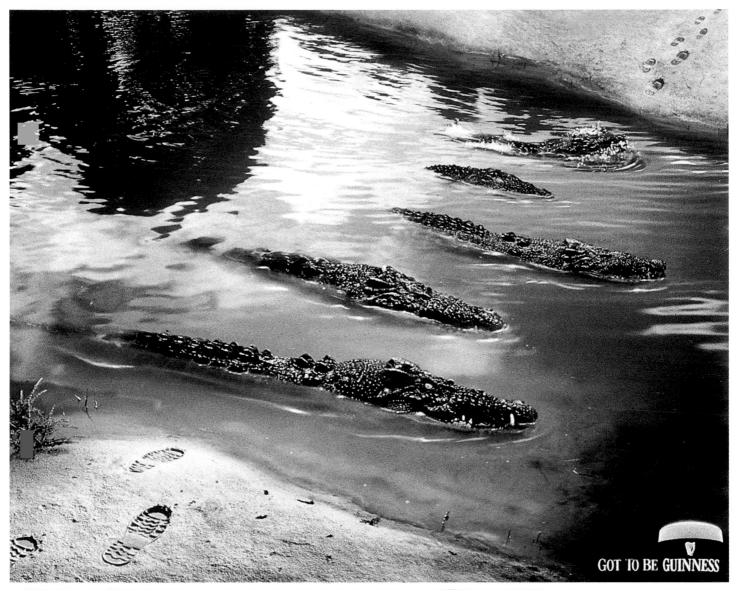

GOT TO BE GUINNESS

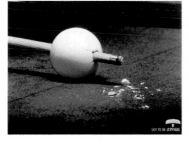

GOT TO BE GUINNESS

AGENCY: Ogilvy & Mather Singapore, 1999
COPYWRITER: Andy Greenaway
ART DIRECTOR: Eugene Cheong
PHOTOGRAPHER: Shaun Pettigrew
CLIENT: Guinness Asia Pacific

Openly exploiting the "macho" aspect of beer drinking—playing on strength, agility, sexual potency etc.—this campaign has something almost Australian about it. On a level of pure cheekiness, my personal favourite is the ad with the crocodiles: it conveys that sort of bold nonchalance every "real" man would like to possess! I expect the ad with the pierced snooker ball— set up in an environment and situation that is typically "bloke-ish"—is a dream come true! Warm colours used in art direction add to the intensity of the message.

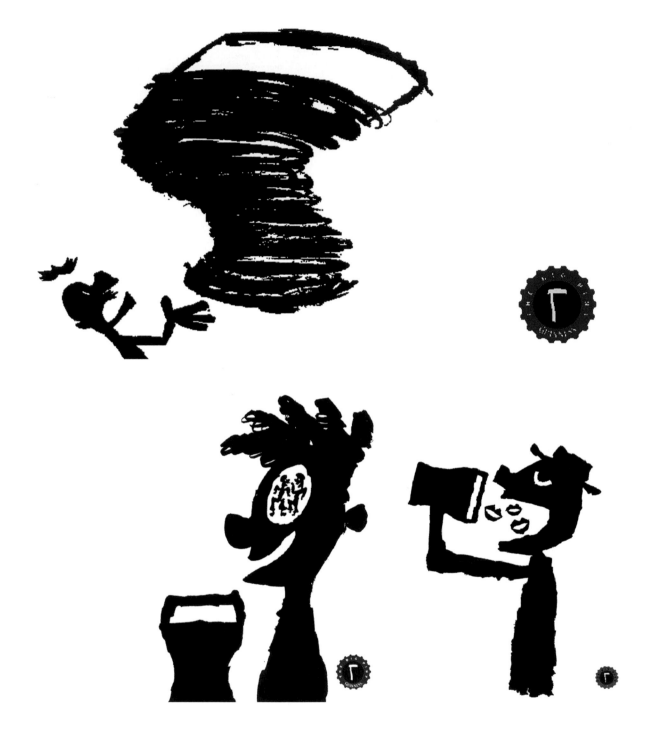

BIG PINT

AGENCY: HHCL and Partners London, 1997/98
COPYWRITER: Al Young
ART DIRECTOR: Mark Howard
Illustrator: Michael Bartalos
CLIENT: Guinness Ireland

Illustration is used relatively rarely in no-copy advertising. It's as though actual photographs are considered more powerful in conveying the message in advertising. This campaign, however, demonstrates how simple, but striking black-and-white posters based on illustration can evoke all the necessary desire to lure "punters" towards a cold pint of beer. The creative team responsible for this ad explains the thinking behind it: "The brief was to create a graphic language for Guinness that was 'big, bold and simple'. We set a restriction of trying to evoke the impact of the 'Big Pint' without letting words get in the way." A certain playfulness and wacky humour radiate from the way the drawings are set out and they become almost cartoon-like.

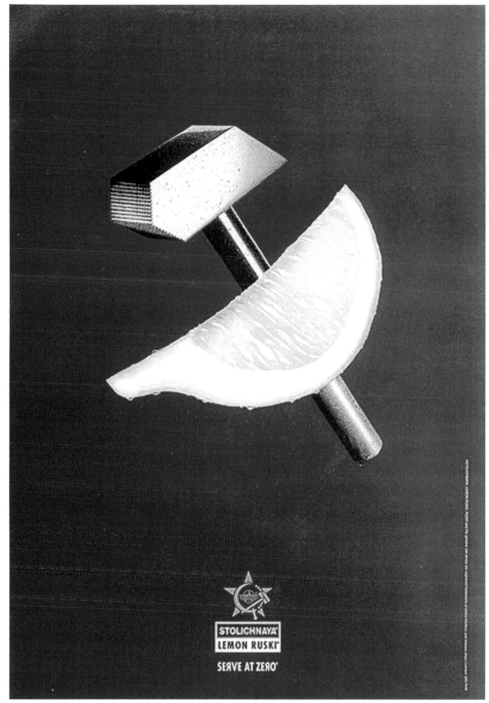

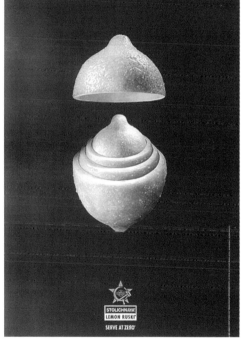

STOLICHNAYA LEMON RUSKI

AGENCY: Leo Burnett Sidney, 1999
COPYWRITER: Sion Scott-Wilson, David Thackray
ART DIRECTOR: John Foster
CLIENT: UDV/Stolichnaya Lemon Ruski

Clean, sharp and simple—just like good vodka. But this time produced "down under" where people, despite the lack of bitter cold and snowy winter, know what a good drink is. The ads play directly on the connection between the product and some of the most iconic imagery associated with Russia. This ad is executed with style and well measured humour. The strong red background undoubtedly contributes to the feeling of "Russianess". David Thackray doesn't beat around the bush when explaining the approach to the campaign: "The thought process for developing this campaign was deceptively simple. The product is made up of genuine Russian Vodka with a lemon flavour—hence the name Lemon Ruski. So why not have images of Russia made from lemons." Typically Australian, I would say.

MUSCLE BONE

AGENCY: Saatchi & Saatchi Singapore, 1998
COPYWRITER: Kelvin Pereira
ART DIRECTOR: Maurice Wee
CLIENT: Klim Milk

The X-ray machine and time-slice technique have become some of the special effects most often used in today's advertising. In this ad the X-ray machine idea has been employed to great effect. The incredibly punchy connection between the product and its benefits is conveyed through a simple picture, with exactly the right atmosphere of a medical X-ray film to make things even more associative. The creative team was very aware of its approach: "The most successful posters make a single-minded proposition quickly. We needed to ensure that people understood our message without having to read copy that explained that drinking hi-calcium milk makes your bones stronger. Hence, a skeletal arm with a bulging bicep."

COMPLAN

AGENCY: Leo Burnett India Mumbai, 1999
COPYWRITERS: Agnello Dias and Gokul Krishnan
ART DIRECTORS: Yayati Godbole and B Ramnathkar
CLIENT: Heinz India

The approach to this campaign has several interesting strategic points already mentioned in the introduction to this book and clearly distinguishable in a statement by Agnello Dias, one of the copywriters: "Over the years, Complan has come to be associated with children's growth and the attempt this year was to further reinforce those values in a simple, telegraphic manner. The intricate benefits of the product were already being communicated by film and, therefore, all one had to do was to cut through to the parents about the overall benefit. Doing so in a charming, succinct manner, using just visuals was a necessity dictated by competitive advertising as well as the parent's usually hectic timetable." The result is very powerful.

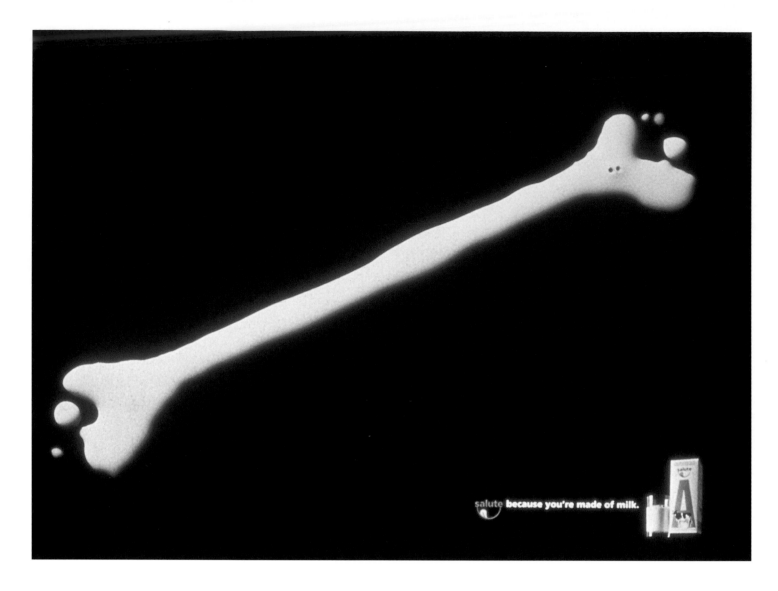

BONE

AGENCY: Almap BBDO Sao Paulo, 1999
COPYWRITER: Cassio Zanatta
ART DIRECTOR: Jose Carlos Lollo
PHOTOGRAPHER: Fernanda Tricoli
CLIENT: Salute

If one were to try and find the perfect example from the Brazilian advertising world—then this ad might be it. Looking at Brazilian ads, you might ask yourself how they manage to make such outstanding ads by the simple presentation of a small number of even simpler elements (see pages 56 and 82) Personally, I think they are maybe the most idea-driven ad country in the world. This is a great example: just a spill of milk, made in the shape of a bone. Enough said!

NIPPLE

AGENCY: M&C Saatchi London, 2000
COPYWRITER: Mike Goodwin
ART DIRECTOR: Tiger Savage
CLIENT: Vogue.com

Both of these masterpieces of simplicity and bold branding have done very well, but "Nipple" caused some additional PR as well. As a poster execution it had just that added amount of cheekiness sufficient to produce stir in Britain. What was it that happened exactly? The ad was intensively discussed and split the advertising community and general public in two camps: one claiming that it is an example of superb advertising, supporting the new online off-shoot of a famous fashion magazine; others insisting it is simply a turkey and a cheap use of shocking tactics. However, the bible of British advertising, Campaign magazine, made it the best press ad in Britain for 2000 (featuring the same ad, oddly enough, in its "Turkeys of the Year" list).

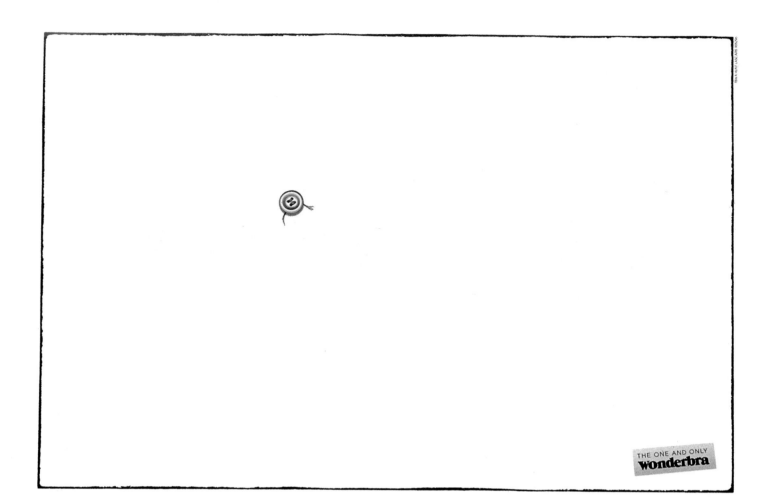

72 BUTTON

AGENCY: TBWA Hunt Lascaris Johannesburg, 1999
COPYWRITERS: Iain Galvin
ART DIRECTORS: Jamie Meitz
PHOTOGRAPHER: Michael Lewis
CLIENT: Playtex/Wonderbra

This ad could be considered an extreme form of no-copy. It's cryptic almost to the point of undecipherability. No-copy fundamentalism. It took a while before I managed to understand it. "When we first came up with the idea," explains Jamie Mietz. "I quickly took a Polaroid shot of a button found at home. After the ad was approved, I visited boutiques, fashion stores and haberdashers in my search for the perfect button. In the end I decided to use the original which is typical!"

BOCAGE
PARIS

BOCAGE
PARIS

BOCAGE
PARIS

BOCAGE

AGENCY: devarrieuxvillaret Paris, 2000
COPYWRITER: Pierre-Dominique Burgaud
ART DIRECTOR: Stephane Richard
PHOTOGRAPHER: Cedric Buchet
CLIENT: ERAM/Bocage

The most interesting fact about this campaign was that the French couldn't understand it, although it was produced by a French agency! The regulations on advertising in France are such that the campaign could certainly have been breaking some of them and this caused a stir. Utterly stylish, as it should be for a fashion brand, it plays on a perceived significance of fashion for a woman's "feel better, look prettier" factor. A connection with cocaine is certainly the most controversial one but it is arguable how many viewers will feel upset by it, given the level of cynicism and sophistication—not to mention experience with various chemicals—amongst the young and hip that this campaign obviously targets. More than likely another cool joke to talk about.

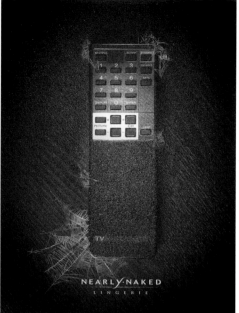

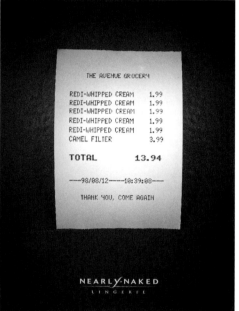

BED
REMOTE
RECEIPT

AGENCY: Palmer Jarvis DDB Toronto, 1999
COPYWRITER: David Chiavegato
ART DIRECTOR: Rich Pryce-Jones
PHOTOGRAPHER: Cedric Buchet
CLIENT: Nearly Naked Lingerie

The drive behind this campaign was the idea of letting the mind play the game of constructing the story, as David Chiavegato explains: "While most lingerie advertisers use the cliched approach of featuring beautiful, scantily-clad models, we felt Nearly Naked's advertising should take a more lateral route by recognising the real motivation behind a lingerie purchase— which, of course, is an enhanced sex life. Simple photographs of the by-products of great sex (an unused television remote control, a receipt for whipped cream and cigarettes, a wall cracked behind a headboard) say it all. As with great sex, great advertising is based on one simple principle: show me, don't tell me."

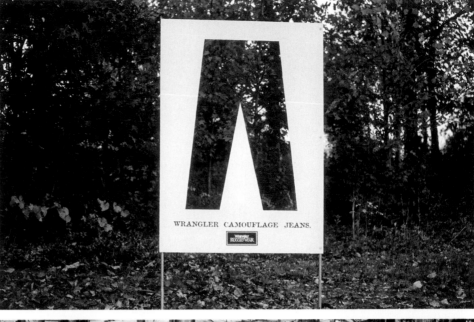

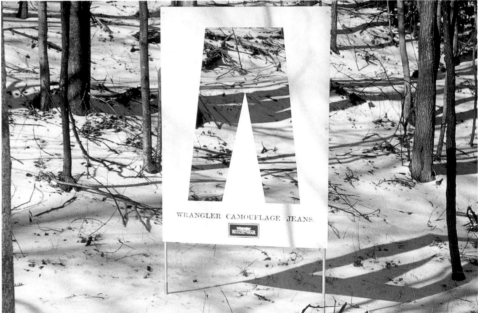

CAMOUFLAGE JEANS

AGENCY: The Martin Agency Richmond, 1998
COPYWRITER: David Oakley
ART DIRECTOR: John Boone
PHOTOGRAPHER: Mike Carroll
STUDIO ARTIST: Judd Burnett
CLIENT: Wrangler Company

Wrangler Jeans has one particular style of jeans called "camouflage"—those patterns emulating various natural environments, similar to army camouflage uniforms. It was a challenging proposition to find the most simple, but compelling way to demonstrate precisely this attribute—to visibly show how invisible they are. This is the reason for camouflage—to appear invisible. The solution in this particular campaign is edging on sheer brilliance: just a simple white board, with a cut-out in the shape of a pair of trousers, placed in front of a natural forest background. This simple solution works throughout the year, and transcends the product itself, powerfully bringing to life the attribute. "It's a really, really simple idea that works whatever the time of the year," explains David Oakley. "People have gone nuts for it. At trade shows we bring in tons of foliage as background. Almost everyone stops and looks at it and says: "Where are the jeans?"

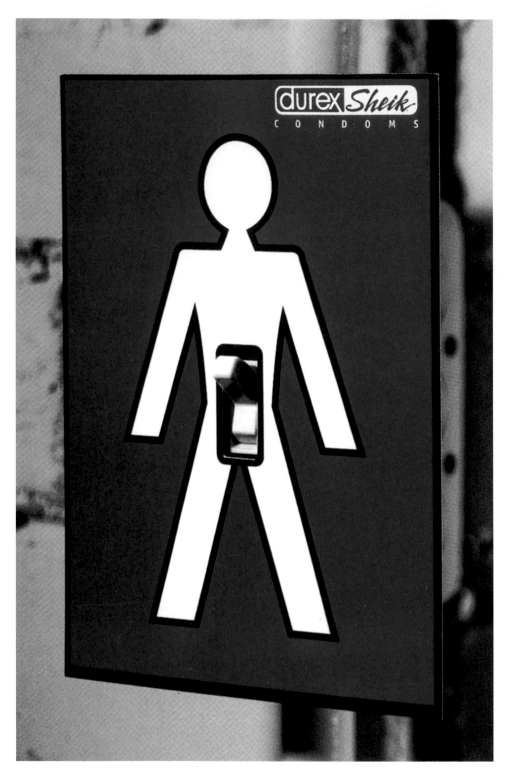

SWITCH PLATE

AGENCY: MacLaren McCann Toronto, 1998
COPYWRITER: Jonathan Frier
ART DIRECTOR/ILLUSTRATOR: Sean Davidson
CLIENT: Durex Canada

This is an example of an extremely successful ambient advertising idea. The ad is actually a large switch plate placed on a wall in one of the busiest streets in Toronto, imitating door symbols for men toilets, and with the switch turned on. It was produced for Durex's Sheik brand of condoms, a campaign that had introduced a generic Durex brand name over the local brand names. The agency conducted extensive research into the target market (young people) and found that they were aware of the need for safe sex, but didn't want to be forced into using one brand of condoms over another. Hence, the communication in this campaign had to be fun, pleasurable, sensuous, sexy and trustworthy. Basically, to stress the return of fun back into sex, as some of the respondents said: to "protect, but to allow pleasure" as well. The agency even came up with a name for such a strategy: Positive Controversy.

The result was fascinating. Media coverage of the campaign was tremendous and even included news crews doing live stand-ups in front of the wall ad! Brand awareness for the client rose from only 8 per cent to 29 per cent and the campaign won some of the most prestigious international ad awards.

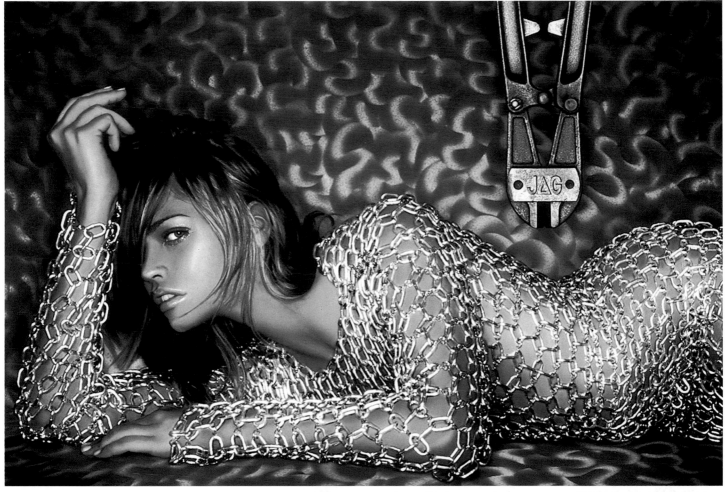

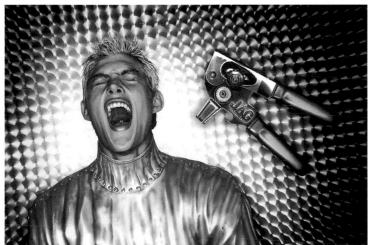

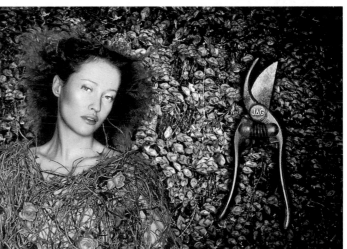

JAG

As confirmation to the question on the selling power of no-copy ads, here is a revelation from a DDB team: "The JAG brand was in steep decline since the mid-1990s. However, it has experienced renewed vigour, popularity and awareness since the launch of the campaign in fashion magazines and transit. An outstanding shift in brand perception (for a fashion retail campaign showing no product at all). The idea has been incorporated into in-store visual merchandising and Jag Salon shows at the 2000 Melbourne International Fashion Festival."

AGENCY: DDB Melbourne, 2000
COPYWRITER: Steve Sorec and Michael Faudet
ART DIRECTOR: Katerina Bojcuk
CLIENT: Palmer Corporation

CHAIRS

AGENCY: Saatchi & Saatchi Singapore, 1999
COPYWRITER: Peter Moyse
ART DIRECTOR: Rashid Salleh
PHOTOGRAPHER: One-Twenty-One Studio
CLIENT: Toyota

"Comfort" is what these ads scream about! Aimed at families, a simple set of chairs arranged in the shape of the Toyota Spacio seats projects the sense of community and good time had while driving. The ads are one succulent metaphor for the best feature a family car can have: comfort for everyone. Again, as with many other ads in this book, there is a direct connection here between the product advertised and everyday objects. The execution of the campaign is exemplary in its clarity, style and intelligence.

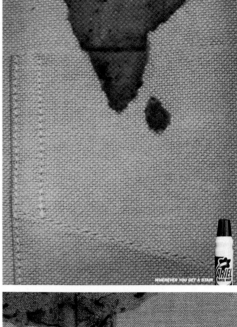

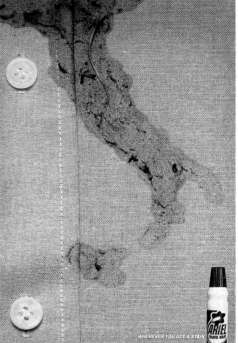

GEOGRAPHY

AGENCY: Saatchi & Saatchi London, 1998
COPYWRITER: Richard Baynham
ART DIRECTOR: Ian Gabaldoni
PHOTOGRAPHER: Mark Wright
CLIENT: Procter & Gamble/Ariel

In every country there is a certain food ingredient which immediately springs to mind when you think of that particular place and the campaign for Ariel Travelwash, a well-known detergent, plays very strongly on this association. "The ads combine a simple stain appropriate to each country (e.g. Italy and pasta sauce), in the shape of that country," explains the creative team. "The line has a double meaning—'wherever' in the world or 'wherever' on your clothes, you get a stain, Ariel Travelwash will get it clean." Other examples were Australia with wine, India with curry and North America with ketchup.

CRUNCH GYM

AGENCY: DiMassimo Brand Advertising New York, 2000
COPYWRITER: Phil Gable
ART DIRECTOR: Sandra Scher
ILLUSTRATOR: Sara Schwartz
CLIENT: Crunch Gym

Advertising for the world of beauty and fitness centres can sometimes be a vanity parade: beautiful bodies and a hard sale usually accompanies it. An alternative to this standard would be something a little more sophisticated and tongue-in-cheek. This campaign for Crunch tried the alternative route: "Anything other than 'you should look like a chiselled demi-god' is an unusual message in the fitness category" says Sandra Scher. "These 'Inspirational Workout' posters provide unexpected, completely absurd reasons to workout at Crunch. The goal of the campaign is simply to show people that Crunch is a fun, comfortable gym where they won't feel self-conscious. The idea of showing absurd benefits from working out came from a student advertising project that I did while at the School of Visual Arts."

Pulligan Pantyhose Strong Series **PULLIGAN**

PULLIGAN STOCKINGS

AGENCY: F/Nazca S&S Sao Paulo, 2000
COPYWRITER: Wilson Mateos
ART DIRECTOR: Sergio Barros
PHOTOGRAPHER: Rodrigo Ribeiro
CLIENT: Pulligan

"Stockings twist and tear very easily. Any woman knows that. However, the stocking industry seems to be completely unaware of this fact! Pulligan has solved this problem by creating a stronger and more resistant stocking. The mission was to promote it with a press ad campaign. Where could a stocking be twisted without tearing and prove it's more resistant? Then the idea for the ad was born," explains the creative team responsible for this ad campaign.

SCARS

AGENCY: CLM BBDO France, 2000
COPYWRITERS: Guillaume Delacroix
and Frederic Temin
ART DIRECTOR: Anne de Maupeou
PHOTOGRAPHER: Vincent Peters
CLIENT: Kookai

There seems to be a general consensus among fashion manufacturers that shocking definitely sells. As a series of ads for a new line of womenswear by Kookai, the campaign continues Kookai's strong and (man would say) harsh treatment of the opposite sex. In Kookai's campaign men appear flushed down the toilet, used for cleaning nails or enslaved as expendable midgets on a gargantuan woman's body. The thinking behind this campaign is that the new line has such strong impact it leaves men needing heart surgery. The black background emphasises the morbidity of the ads and makes them highly noticeable. Kookai obviously has its devoted audience and this campaign perfectly continues the saga.

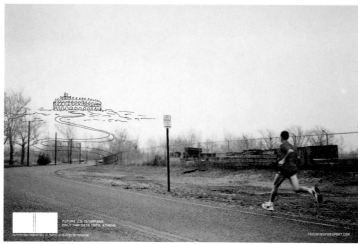

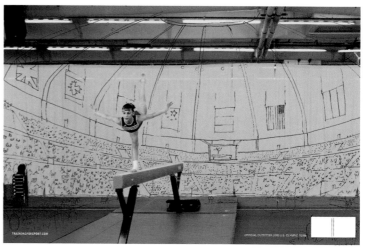

BOXER
RUNNER
GYMNAST

AGENCY: Leagas Delaney San Francisco, 2000
COPYWRITER: Steve Morris
ART DIRECTORS: Sean Ehringer/Brad Wood
ILLUSTRATOR: Sara Schwartz
CLIENT: Adidas

A comment from Sean Ehringer, co-creative director of the campaign, reveals one side of the Olympic sport that is not so glamorous as the big finale every four years, but nevertheless no less dramatic: "The brief for this campaign was 'Olympic athletes are made when no one else is watching.' There were several concepts but none spoke so quietly and powerfully as this one. We wanted to show what a long, lonely training Olympic athletes endure, with only a dream to sustain them; that some day the world might see what they can do. We debated whether the ad needed some further explanation with copy. In the end we felt that copy would have added another voice to the ad and that would have fought against the basic idea of loneliness, of an athlete being alone with their dream."

BLIND MAN

AGENCY: Palmer Jarvis DDB Vancouver, 1999
COPYWRITER: Miles Markovic
ART DIRECTOR: Daryl Gardiner
CLIENT: Palmer Jarvis DDB

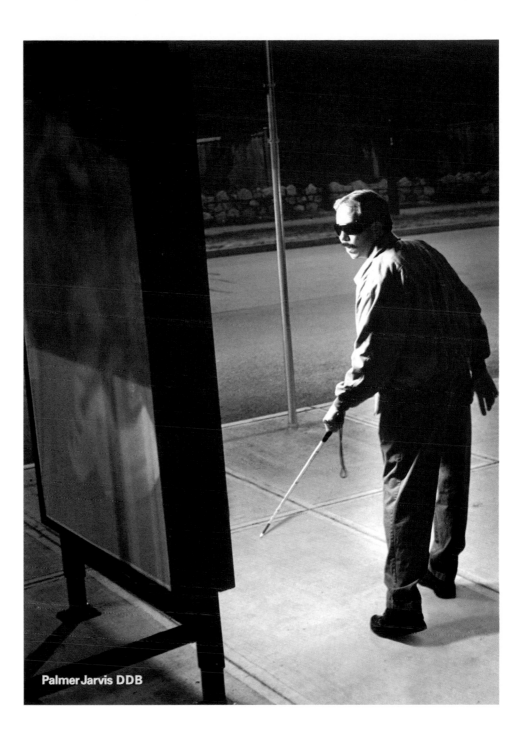

In the perfect world of "vanity advertising"—i.e. ads created to advertise agencies themselves, it is considered acceptable to exaggerate a little. After all, you have to make an impact in the face of a double dose of cynicism: not only from a smart consumer, but from even more cynical prospective marketing or communications directors/managers. However, vanity ads can sometimes be truly exciting and revealing, touching on the very core of how and why advertising works (or what the agency think is their strength) and presenting it in a dramatic manner. Take the above ad, for example: it may seem ridiculous at first, but who wouldn't want an agency capable of producing ads that will make even blind men stop in their tracks and curiously turn to check what's going on. If you still think this is a bit over the top, take a look at what the creative team's original idea was: "In the original layout," says Daryl Gardiner, "we wanted to include a swarm of naked monkeys on and around the blind dude. Our creative director didn't think naked monkeys were funny. That creative director's probably kicking himself now. We sure are."

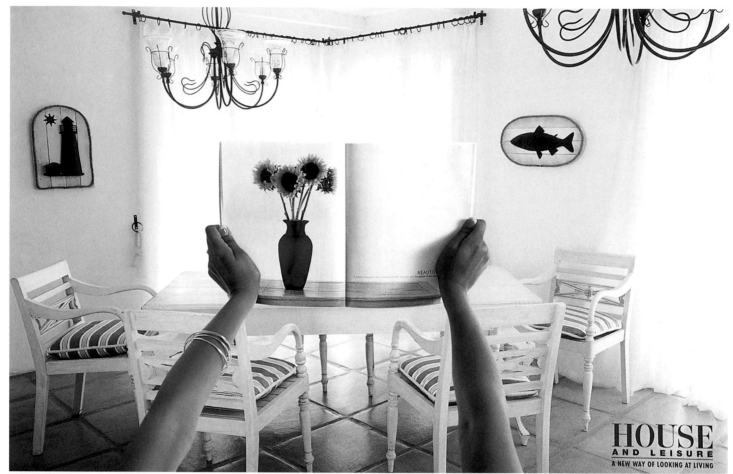

HOUSE AND LEISURE

AGENCY: The Jupiter Drawing Room Cape Town, 2000
COPYWRITER: Anton Visser
ART DIRECTOR: Graham Lang
CLIENT: Associated Magazines/House and Leisure

"Great minds think alike", might be a phrase that comes to mind when looking at this campaign. The solution, seen here, to advertise an interiors magazine is very similar to that arrived at by another agency to promote a diet soft drink. Take a look at the Coca-Cola campaign on page 59 again. These ads for House and Leisure play on the idea of the question readers most often ask themselves: "but, what will it look like in my own home?" The answer is illustrated here in a simple, yet unexpected way. These ads are stylishly art directed and cleverly stress the connection of the product with real life.

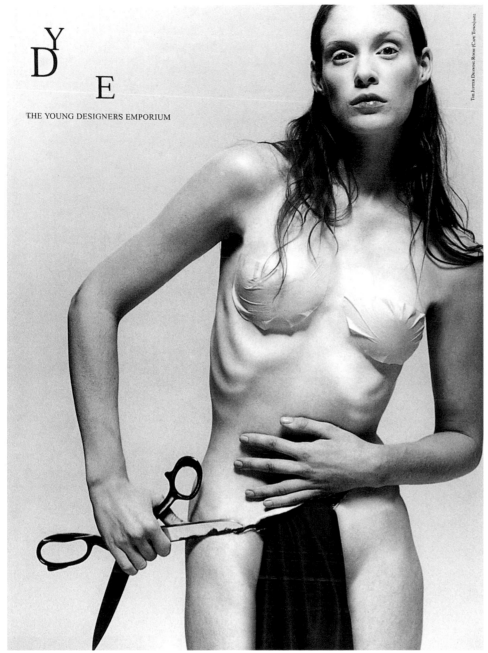

GUT
ZIP
TATTOO

AGENCY: The Jupiter Drawing Room Cape Town, 1999
COPYWRITER: Anton Visser
ART DIRECTOR: Schalk Van Der Merwe
CLIENT: Young Designers Emporium

Gutsy, in the literal sense of the word! This quirky South African campaign is dictated by the client's character: young, in-your-face and provocative. It is stylish, as young fashion designers usually are, but in a disturbing way—a degree of calm beauty and naivety mixed with much stronger death-and-life associations. In the cut-throat world of fashion design, particularly if you are young, it really takes strong actions or statements to stand out. It's hard to persuade the industry that you are passionate about your art, so arresting visual images and a strong message can help.

NATURAL MASTERPIECES

AGENCY: Saatchi & Saatchi New Zealand, 1998
COPYWRITER: Andrew Tinning
ART DIRECTOR: Andrew Tinning
CLIENT: Auckland Regional Council

Advertising is often accused of visually polluting the environment. But in this campaign it cleverly turns this notion on its head: real picture frames are placed in some of Auckland's most beautiful natural spots and then photographed for the print ads. Ambient advertising meets print advertising. In Andrew Tinning's words:

"Auckland as a city gets bagged by the rest of the country as having nothing to show for itself other than traffic jams, power crisis and yuppies. The reality is that we are surrounded by some of the world's most beautiful regional parks. Our job was to bring this alive in the minds of the population. We needed more than just ads. The

parks will be with us forever and in my mind so should the communication. The parks are natural masterpieces, works of living art which we framed as artists have done with their works for countless centuries. The 25 frames are permanent fixtures that will be with us for the next 100 years and beyond."

CAMELS

AGENCY: Travis Sully Harari London, 1999
COPYWRITER: Gill Sully
ART DIRECTOR: Andy Lawson
PHOTOGRAPHER: Peter Lavery
CLIENT: The English Riviera Tourist Board

"It began in 1982 when the original palm tree poster was created. The agency (TRAVIS as it was known as then) re-invented three English seaside towns as the English Riviera and the most famous domestic tourism campaign began life. Seventeen years later the palm tree icon clearly still had life in it, but how could we take it further creatively? The idea of putting up that first English Riviera poster in an exotic location appealed to a fitting sense of English irony. That the residents of Marrakesh should find the attractions of Torquay, Paignton and Brixham so compelling is a humorous, but very affectionate tribute. The photographer Peter Lavery captured the atmosphere of Morocco with such reality that the juxtaposition between the charms of home and abroad were there for all to see."

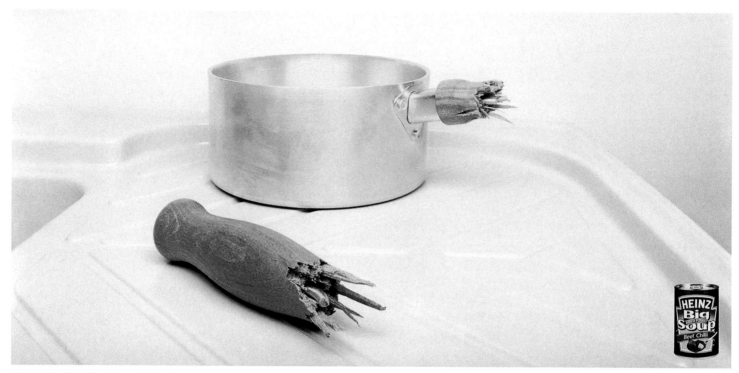

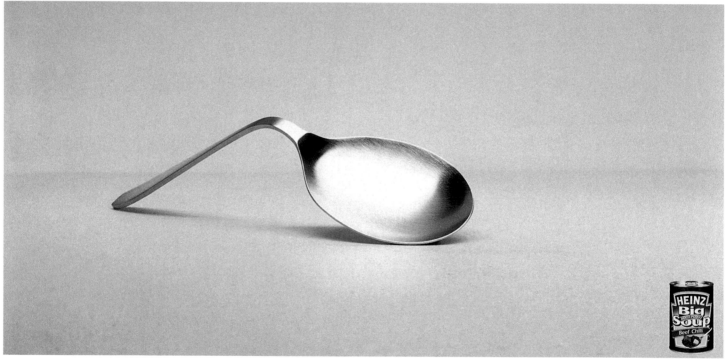

BIG SOUP

AGENCY: Leo Burnett London, 2000
CREATIVE TEAM: Paul Miles and Adam Staples
CLIENT: Heinz/Big Soup

Soup. Heavy. Strong. Rich. Dense like part of a neutron star. Hey, this is advertising! But this is exactly what the point of the campaign is. How and why? Let the creative team explain: "It always helps if your product says something blatantly obvious. In this case we are in no doubt that we may encounter large chunks of vegetable matter when opening a can of 'Big Soup'. It's dense. So forget the strap-line, it's time to let the visuals do the work. What images relate to the preparation and consumption of soup eating? Bowls, tin-openers, pans, spoons... Without Uri Geller's help we bent a spoon, not a soup spoon though, because that wouldn't be 'studenty' enough. Then we broke the handle of a bog standard saucepan. The resulting images said a great deal about a product which didn't need much introduction itself as to what it was offering."

Not every TV is kids' TV

DRAWINGS

AGENCY: MARK/BBDO Prague, 2000
COPYWRITER: Viktor Spala
ART DIRECTOR: Ondrej Karasek
ILLUSTRATOR: Ondrej Karasek
CLIENT: Agency project

"It was not like I found my son drawing pictures like these and thought, well, let's do this," says Viktor Spala. "We were choosing from about 20 topics and it was at the time when the violence on TV was discussed a lot and different parental groups required banning TV serials like South Park. That is not a solution, though. The campaign is targeted at parents with children at pre-school age. The older ones are hard to control." Ondrej Karasek continues: "I thought the best idea would be to let children express themselves and let whatever they see on the TV screen speak through them. Even though the drawings look very believable they weren't drawn by my children. I myself had to go back to my childhood. You have to bend in a certain way to find the right position. I've tried it with my left hand, with my foot and even with both feet!"

DIESEL

AGENCY: Paradiset DDB Stockholm, 1996/1998
CREATIVES (on all or some of the ads): Joakim
Jonason, Linus Karlsson and Jacob Nelson
PHOTOGRAPHERS: Peter Gehrke
and David La Chapelle
CLIENT: Diesel

The impact that Paradiset DDB's campaigns had on building the Diesel image and sales are hard to measure—it's simply enormous! The ads shown here are part of a continuous stream of extremely quirky looking posters that caused a lot of interest and, sometimes, outrage, all over the world. Always surreal and often dream-like, they are the ultimate exercise in image differentiation, covering at the same time some of the cultural and political issues of the moment. Sometimes it's a modern obsession with slim-looking people and extremes of health and fitness. Sometimes, as is the case of the poster showing two sailors kissing, gay issues are being challenged. This ad coincided with the end of the Second World War and when US president Bill Clinton decided to allow gay people to serve in the army on condition that they kept their sexual orientation under wraps. So, "don't show, don't tell" was officially accepted as a policy, with all its hypocritical baggage. The interesting thing about this campaign is that it ran globally and almost a hundred different posters were developed over the course of time. Everything was, additionally, supported by strong TV works in the same vain as the print/poster ones (as you can see on pages 122 and 123).

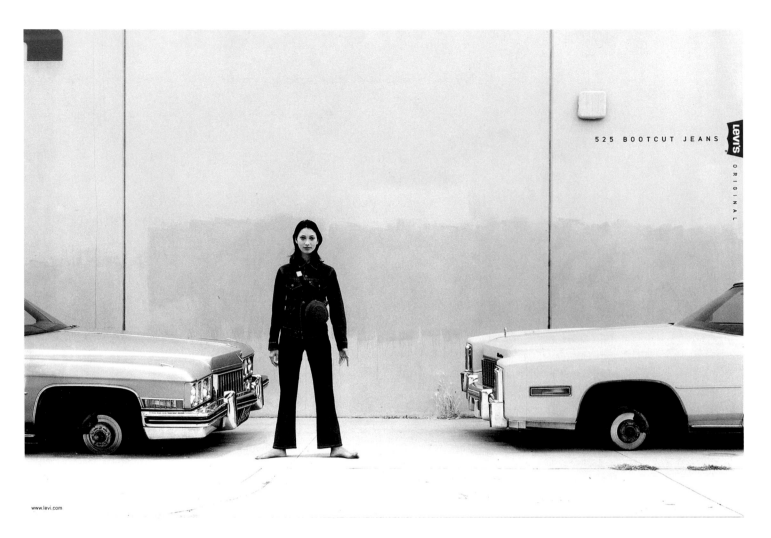

525 BOOTCUT JEANS

LEVI'S® ORIGINAL

www.levi.com

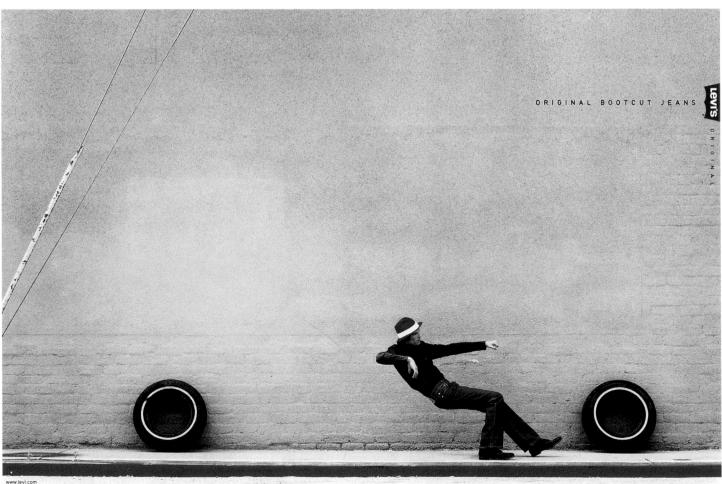

ORIGINAL BOOTCUT JEANS

LEVI'S® ORIGINAL

www.levi.com

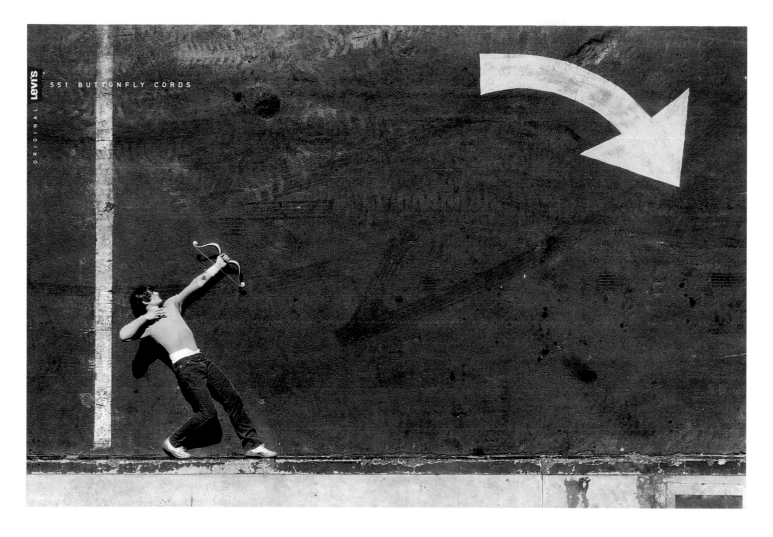

ORIGINAL Levi's

551 BUTTONFLY CORDS

95 LEVI'S

AGENCY: Bartle Bogle Hegarty London, 1998/1999
COPYWRITERS: James Sinclair and Kim Papworth
ART DIRECTORS: Tony Davidson and Ed Morris
PHOTOGRAPHER: Nadav Kander
STYLING: Nick Griffiths
TYPOGRAPHER: Andy Bird
CLIENT: Levi Strauss

With its highly distinctive and polished yet provocative work, BBH had given the Levi's brand almost unprecedented appeal in a modern global market. From print and poster to highly acclaimed TV works, everything in this campaign bears the mark of the highest quality: from the idea itself, through perfect models, to the masterful photography of Nadav Kander. The scenes are surreal, almost derived from the traditional mime discourse. Both brain and eye had freedom to roam here, creating a strange but involving atmosphere. Although the majority of photos are shot in front of some large surface, usually a wall, there is an incredible depth to them.

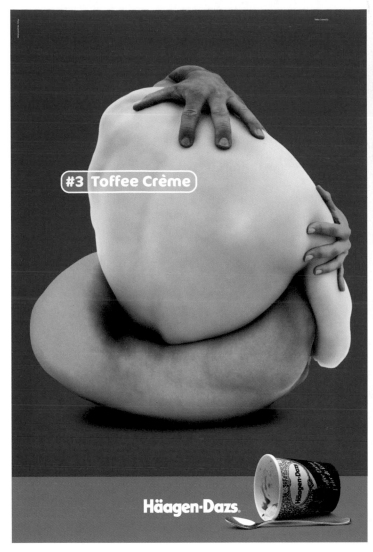

HAAGEN-DAZS

AGENCY: Leo Burnett Connaghan &
May Melbourne, 2000
COPYWRITERS: Derek Craig and Shapoor Batliwalla
ART DIRECTOR: Tone Walde
PHOTOGRAPHER: Howard Schatz
CLIENT: Pillsbury Australia/Haagen-Dazs

Here's what the authors said about this arty campaign: "For a long time Haagen-Dazs advertising was associated with sensuality, with couples shot in black and white, eating ice cream with or off any part of their partner's bodies. Since these heady days things have moved on. Images like these are passé, no longer daring or remotely 'wow!'. Yet the proposition remains.

Haagen-Dazs is still rich, textured ice cream at the top end of the market and still 'Dedicated to Pleasure'. Our challenge was to give that notion of sensuality a new relevance, a new lease of life, in a style befitting to the brand and the contemporary Australian environment in which it would be seen. The campaign was primarily seen outdoors so it had to be bold and arresting.

Howard Schatz, a New York-based photographer, captured the style we were looking for. The outdoor ads work like pieces of contemporary art rather than visual pollution, to extend the long running campaign theme of sensual pleasure in a way that is completely target-market friendly."

SHARK
RHINO
SCORPION

AGENCY: Ogilvy & Mather Bangkok, 2000
COPYWRITER: Saranya Maleipan
ART DIRECTORS: Wisit Lumsiricharoenchoke and
Sompoirn Laokittichok
PHOTOGRAPHER: Fahdol Na Nagara
CLIENT: Fisherman's Friend

Whoever's tried a Fisherman's Friend knows exactly what this campaign is all about. Although small they are one of the strongest pastilles on the market, killing germs and anything else that had the misfortune to be in our throat or nose at the time. They sting, they bite, they hit, they're strong. An interesting angle is the use of origami to represent the above mentioned animals, made out of a Fisherman's Friend packet and associated with their potent characteristics. There is an almost leisurely element of danger radiating from the ads, a playfulness of something so assured of its strength that it doesn't need to prove it.

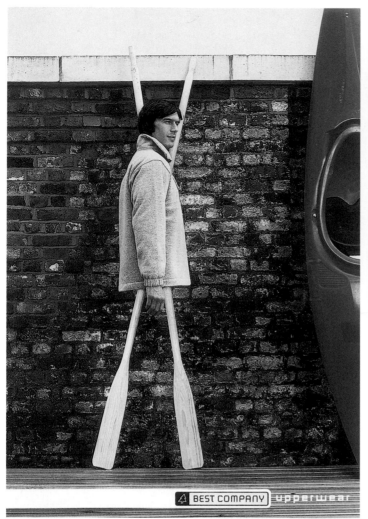
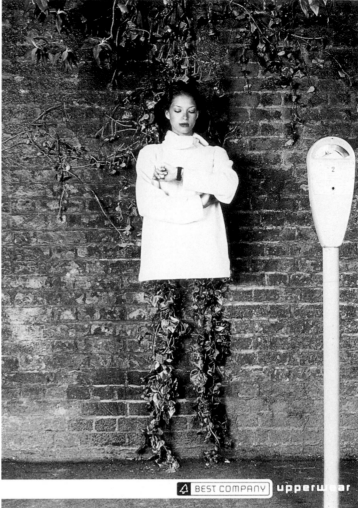

UPPERWEAR

AGENCY: JWT Milan, 1999
COPYWRITER: Andrea Stillacci
ART DIRECTOR: Cristiana Boccassini
CLIENT: Pepper Industries/Best Company

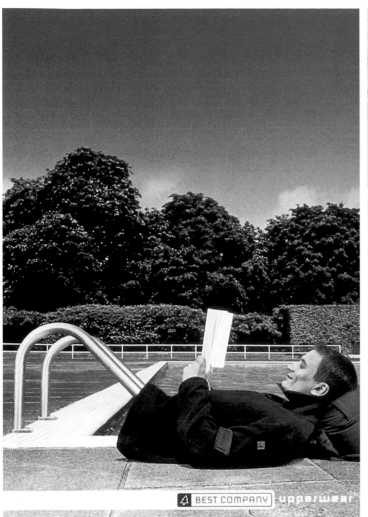

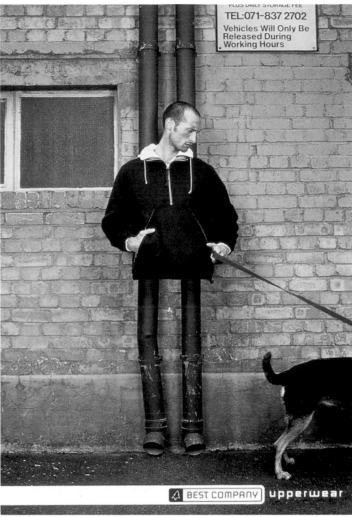

There is something slightly bizzare and dark In this eye-catching campaign. Somehow, seeing a beautiful model in a perfectly struck pose, styled and expertly shot, but without the lower part of their body, invokes an atmosphere of something rather "twisted". This is undoubtedly why it became the right vehicle for post-post-modern, rave-generation humour. The illusion of legs, at first sight at least, is achieved with some every-day street/home objects. "This idea came straight from the product," said the creative team. "Best Company is an Italian clothing company that makes clothes only for the upper half of the body. 'Upperwear' seemed to us to be a perfect encapsulation of that position. The goal then was to visualise them in a way that forced you to look twice at the ad. I think we succeeded."

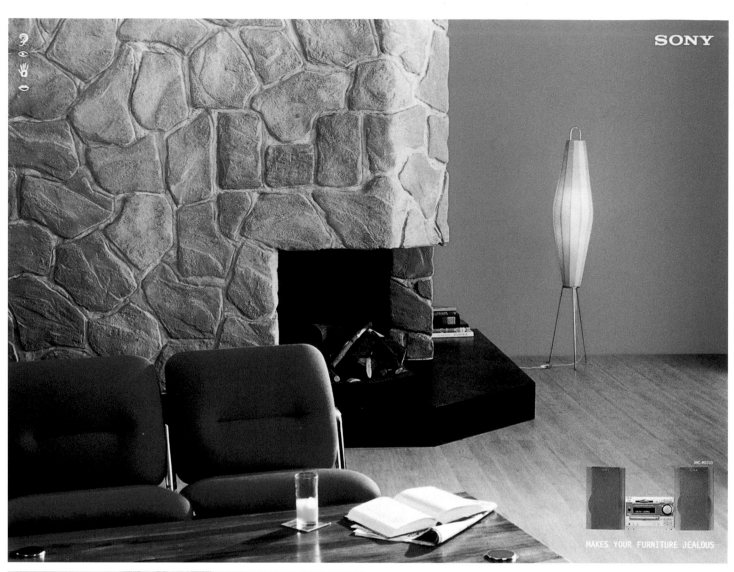

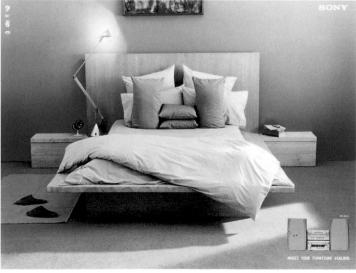

FIREPLACE
BEDROOM
BATHROOM

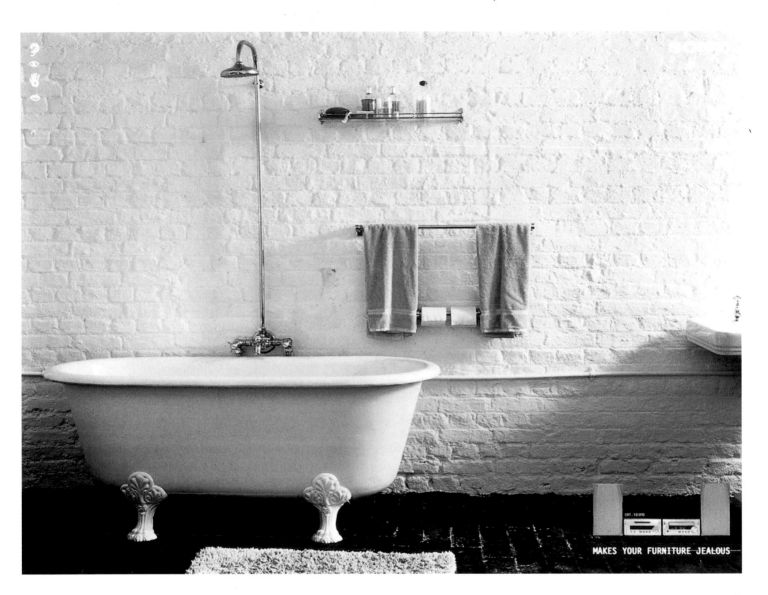

MAKES YOUR FURNITURE JEALOUS

AGENCY: Leo Burnett Warsaw, 1999
COPYWRITERS: Kerry Keenan, Lechoslaw Kwiatkowski
ART DIRECTOR: KC Arriwong
PHOTOGRAPHER: Jonathan Root
CLIENT: Sony Poland

Not many words are needed here: colourful, playful and stylish. Creatives often rely on strong and sophisticated images when representing music, or musical products, in ads. The eye is obviously the ear's best friend. And, as for the idea behind the campaign? Simple, said the creative team: "Imagine a product so well designed that when you introduce it to your home, it makes other elements in your home feel envious and insecure. That is the idea behind this campaign."

BIG MAC

AGENCY: FUTURA DDB, 2001
COPYWRITER: Saša Eržen
ART DIRECTOR: Tina Brezovnik
CLIENT: McDonald's

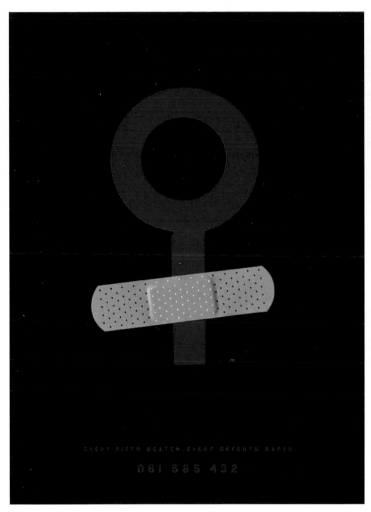

VIOLENCE AGAINST WOMEN

AGENCY: STB Saatchi & Saatchi Ljubljana, 1999
COPYWRITER: Vladan Srdić
ART DIRECTOR: Vladan Srdić
ILLUSTRATOR: Vladan Srdić
CLIENT: New Moment Magazine

DOPING

AGENCY: STB Saatchi & Saatchi Ljubljana, 2000
COPYWRITER: Vladan Srdić
ART DIRECTOR: Vladan Srdić
PHOTOGRAPHER: Aljoša Rebolj
CLIENT: Mladina Magazine

Moving pictures

No-Copy

Advertising

TV & CINEMA

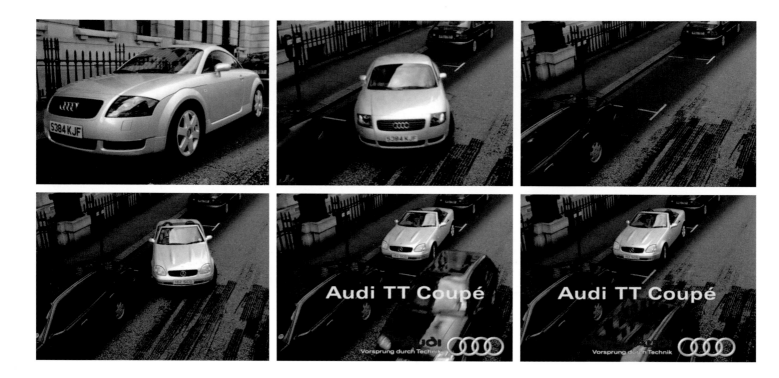

AGENCY: Bates Norway, 1998
COPYWRITER: Aris Theophilakis
ART DIRECTOR: Torbjorn Naug
DIRECTOR: Jorn Haagen
CLIENT: Audi

Spoofs, as a "literary sort" in advertising, are usually either total flops or, if successful, a bit of a controversial matter that evokes all kinds of talk about the origin of creativity, originality and post-modern "quotation" principles. This ad is almost a sacrilege, given the cult status the original idea had built over time, but like all sacrileges it is at the same time revealing, exciting and downright sobering. It shows that there is no symbol in advertising that cannot be used against itself, and the more popular the symbol is, the greater the impact. For an advertising professional it is also a hilarious idea! Simply one of the best spoof ads in recent times and one of the finest examples of a comparative advertising with a brain. "We decided that the main feature of the TT was its unique design. In our view, the famous Mercedes SLK ad should have been made for the TT. So, we reconstructed the story to tell the 'story behind the SLK ad': the skid-marks were from the TT that had stood there before the SLK." Aris Theophilakis and Torbjorn Naug

SNOW COVERED

AGENCY: Bozell New York, 1994
COPYWRITERS: Gary Topolewski/Pete Pohl
ART DIRECTOR: Andy Ozark
DIRECTOR: Eric Saarinen
CLIENT: Chrysler Corporation/Jeep

Remember Trevor Beattie's words on finding inspiration for ads from life? Well, Andy Ozark certainly has something to add to support that, especially knowing that the ad has won Grand Prix in Cannes: "The spot known as 'Snow covered' was, like many ideas, inspired by quite a few things: Firstly, 'Tremors', the highly underrated cinema masterpiece starring Kevin Bacon. The way it showed a monster moving underground was pretty cool. It left a lot to your imagination and I thought it was a good device to use to create interest in a commercial. Secondly, Bugs Bunny. Although, the idea really didn't come from cartoon, it was a quick way to describe the idea to the group. After all, more people are probably familiar with Bugs Bunny than the movie 'Tremors'. And finally, all those Michigan drivers who fail to properly clean off their brakelights after a heavy snowfall need to get special recognition. It's hard to believe that after all these years of winter road rage something positive would come out of it. I always thought that this part of the idea might not be clear to someone who hasn't had the pleasure of driving in Michigan in the winter."

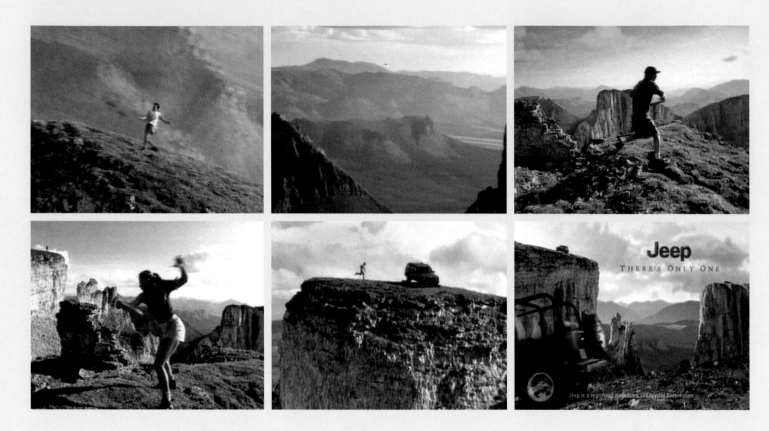

110

FRISBEE

AGENCY: Bozell New York, 1996
COPYWRITER: Mike Stocker
ART DIRECTOR: Robin Chrumka
DIRECTOR: Zack Snyder
CLIENT: Chrysler Corporation/Jeep

Rich, warm colours which generate a sense of "heat" have become something of a trademark for Jeep advertising. The story supporting the visual expression here is really very clever. Mike Stocker has a very sound strategic explanation for this stunning piece: "Extreme sports were just gaining popularity at the time we were creating a new spot for Jeep. That fact led us to wonder if extreme sport Jeep owners might like to play. What we came up with was Frisbee throwing at 15,000 feet. Next we had to work in the Jeep 4x4s. So we had one of the players miss the Frisbee and watch it fall hundreds of feet down. That revealed the true object of this sport. Namely, the joy of racing down the mountain to get the Frisbee."

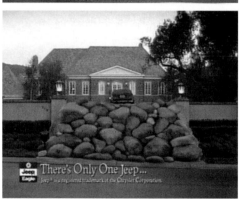

There's Only One Jeep...
Jeep® is a registered trademark of the Chrysler Corporation.

GATES

AGENCY: Bozell New York, 1994
COPYWRITER: Rick Dennis
ART DIRECTOR: Michael Corbeille
DIRECTOR: Michael Grasso
CLIENT: Chrysler Corporation/Jeep

"In early 1995 sport utilities were just starting to become popular," reminisces Rick Dennis. "We had launched the Grand Cherokee a few years before and now the market was becoming crowded. Not only was the competition stealing Grand Cherokee's design but our campaign as well. Suddenly everyone was making a sport utility and shooting it in some natural setting. What we did was to look at it this way; Jeep Grand Cherokee is a luxury vehicle. Let's take nature and move it to the city. The initial thought had been to put a log cabin with a muddy driveway in the middle of Beverly Hills California a la 'The Beverly Hillbillies'. A three-part joke— mansion, mansion, log cabin with muddy driveway that the Grand Cherokee drives into. We later changed it to a pile of rocks around the log cabin that the Grand Cherokee climbed over. Then the gates were added and we reduced the spot to its essence and we were done. I tried writing copy for 'Gates' for months, but the visual is so strong that the copy never worked. It was a valuable lesson; my art director and I try to make the visuals do as much of the talking as possible. If a picture's worth a 1000 words, in film that's 30,000 words a second. Do the math."

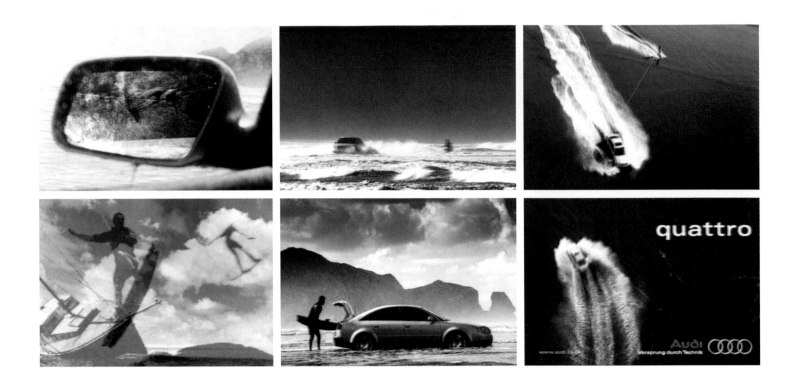

WAKEBOARDER

AGENCY: Bartle Bogle Hegarty London, 2000
COPYWRITER: Nick O'Brian-Tear
ART DIRECTOR: Al Welsh
DIRECTOR: Danny Kleinman
CLIENT: Audi AG/quattro

This startling ad, showing Audi quattro pulling a water-skier through shallow waters, was a phenomenal undertaking. The creative team reveals some amazing details: "Our starting point for the commercial was one of the oldest, but most effective tricks in the book: the product demonstration: quattro four-wheel drive provides incredible grip, especially in the wet. So, we thought, what better and more dramatic way to demonstrate this by driving the car in water deep enough to pull a water-skier. (It might not be a coincidence that both my creative partner and I are keen water-skiers.) The commercial was shot for real. It had to be, otherwise the ad would just be seen as a wild overclaim. The wakeboarder was the New Zealand champion and the cars were sealed to prevent seawater getting into the engine bays. (Amazingly, all four cars we used kept going through two weeks of shooting despite being driven in nine inches of water every day!) We deliberated about having copy and/or voice over, but in the end we decided that no words could improve on what 60 seconds of footage had amply proved. Perhaps as a result of this the ad ended up being aired in 56 markets around the globe."

ROBOTS

AGENCY: EURO RSCG Works France, 2000
COPYWRITER: Olivier Desmettre
ART DIRECTOR: Fabrice Delacourt
DIRECTOR: Eric Coignoux
CLIENT: Citroen

A slightly Asimov-ish ad showing a row of robots in a car factory. Instead of painstakingly welding car parts one of the robots is killing time drawing scribbles on the cars' chassis. Suddenly spotting a manager approaching, the robot quickly adds a layer of a paint to cover up what it's done. The manager is a bit suspicious, but carries on. The robot finishes the operation by autographing each car with one quick "Picasso" signature, which is the name of the model. Heavily relying on computer animation, the ad is slick and colourful and manages to project the feeling of technology with the soul.

AGENCY: McCann Erickson Rome, 1999
COPYWRITER: Fabio Bartolomei
ART DIRECTOR: Claudia Chianese
DIRECTOR: Marius Holst
CLIENT: Opel

STAR SILVER

What happens if two loyal Opel Tigra drivers, both young and attractive, meet at a railway crossing and consider developing an affair? The answer is quite sudden and unexpected: when they envisage family life with kids and an ugly, cumbersome estate car they both hit the accelerator and speed off in different directions! Obviously the desire to drive the Tigra was too strong. Fabio Bartolomei explains the thinking behind the ad: "A new competitor, Ford Puma, had just gained the leadership of the small coupe sector. The Tigra was already 5 years old and there was nothing new to say about it. What could be done? The decision was made to confirm to the reference target that the brand was the most interesting, the trendiest, the closest to them, and the one that knew them best. Tigra: the new-generation coupe was the car's positioning. This had to be reasserted with renewed vigour and effectiveness. We outlined its personality by representing the personality of this new generation of young people. Once again we let them say—the Tigra is my car. That was the strategic background. The actual creative idea, as usual, came to us in a completely round-about way and was triggered by the customer's chief request: to see lots of car in the ad. We began to think about what this really meant. Would 20 seconds of car be enough? Would they want 30 seconds? And then, almost as a joke: okay, but if there were two Tigras, then perhaps we could halve the time! The rest followed on from there. The film went on the air twelve days later; in the heat of the moment we also halved the time it is humanly possible to work on such a project!"

THE ONLY BRUSH WITH DEATH
YOU'RE LIKELY TO HAVE IN A VOLVO.

HAPPY ENDINGS

AGENCY: Saatchi & Saatchi New Zealand, 1999
COPYWRITER: Andrew Tinning
ART DIRECTOR: Andrew Tinning
DIRECTOR: Richard Gibson
CLIENT: Ovlov/Volvo

A slightly bizarre piece of work, the ad is actually a winner of a competition opened by Auckland production company Silverscreen. They shot a 20-second opening sequence featuring a man walking through the streets holding a toilet brush. 50 regional agencies were then challenged to complete the ad and tie it in with one of their clients. In Saatchi's finale, the man meets Death and exchanges the toilet brush for a scythe. Death gets into a car (a Volvo, of course), hangs the brush as a souvenir and drives away. A strap-line suggests that this would be the only brush with Death you will have in a Volvo. Andrew Tinning says: "The task was to take the established proposition of safety and give it an unexpected twist. Among younger consumers Volvo is perceived as being serious and conservative. With the introduction of a new range of sleeker sexier models that broke the 'shaped like a box, built like a tank' stereotype, we felt it was time to reward the audience with an ad that did the same." The Saatchi team came top of 120 entries.

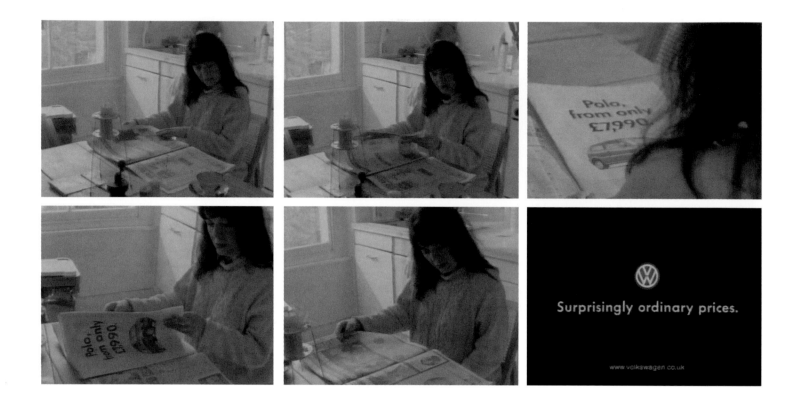

HICCUPS

AGENCY: BMP DDB London, 1999
COPYWRITER/ART DIRECTOR: Andrew Fraser
DIRECTOR: Johnny Maginn
CLIENT: Volkswagen/Polo

This is one of the ads from a legendary series that have spurned a new interest in the client's product in the UK. This is going to sound like a teenage memory, but I have to say it: I remember the first time I saw the ad during the Cannes Lions festival. From the first frame, everyone in the room knew that this was no ordinary ad: a woman flicking through a newspaper and occasionally having hiccups until she gets to the page announcing the price for a new Polo. Nothing spectacular happens—she looks at the ad and then continues to browse the paper. Only that she has stopped hiccuping from the moment she saw the ad. I don't think shock has ever previously been portrayed so calmly and understated as in this ad! A triumph of the English thought process and intellect. The atmosphere is supported by the documentary style execution, almost "fly-on-the-wall", with faded colours and natural background noises.

 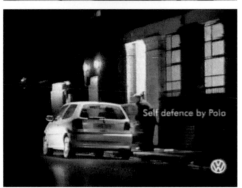

SELF DEFENCE

AGENCY: BMP DDB London, 1999
COPYWRITER: Andy McLeod
ART DIRECTOR: Richard Flintham
CLIENT: Volkswagen/Polo

A visual puzzle that stands up to scrutiny even after repetitive viewing. Just a series of enigmatic moves, noises and thoughtful sensi, leading the viewer to think that this is the practice of some strange martial arts discipline. It turns out to be a familiar set of moves that a driver carries out when preparing to start driving a car. In this case, the VW Polo.

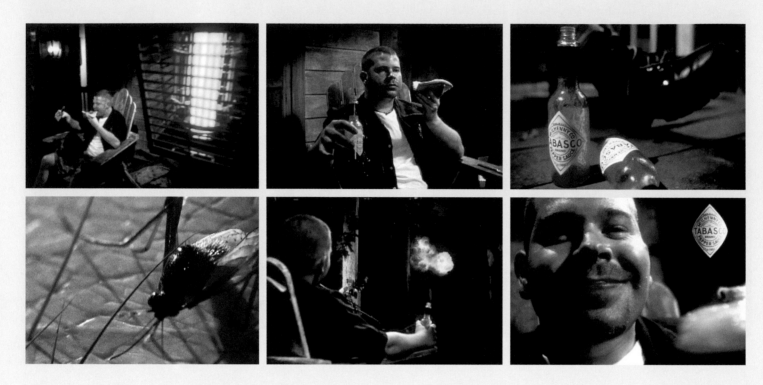

MOSQUITO

AGENCY: DDB Dallas, 1997
COPYWRITER: Galen Greenwood
ART DIRECTOR: Tom Moudry
DIRECTOR: Dick Buckley
CLIENT: The McIlhenny Co.

It begins in silence: just a hot, quiet Southern night. A man is sitting on the porch of his shack eating pizza heavily sprinkled with Tabasco. A mosquito appears and lands on the man's arm where it begins having a sumptuous dinner. The man doesn't react— no slapping, none of the usual mosquito-defence karate—just an uninterested look. A few seconds later we know why: as the mosquito tries to fly away it explodes in mid-air. The man smiles cunningly. Tabasco sauce is so hot that even the blood of its consumers gets fiery hot. Better be strong enough to take it. Who said that USP advertising cannot be creative? Another great example of product feature dramatisation. "One of the assignments of this commercial was to demonstrate that Tabasco consumers exhibit 'courage under fire'. We do this by showing our principal character's unflinching and generous consumption of Tabasco's 'fiery' sauce. And to a certain extent, we also see this courage in his cool and calm demeanour when confronted by a ravenous mosquito. In a sense, the spot is the classic showdown. The key to this commercial's success is the strength and simplicity of the idea. We had a lot of discussion about who should direct the spot. Of course, our initial thought was to have a comedy director shoot it. But it became evident that the last thing we should do was to try and 'make' this commercial funny. We decided to concentrate our efforts on casting the right guy, and shooting the story straight—no comedic elements, no shtick or buffoonery. The film was shot and edited in a way that creates great tension between man and mosquito. The viewer knows that something's going to happen, they just don't know what that 'something' is. Contributing to this suspense is the lack of music. The agency had originally explored licensing the track 'Love Hurts', (as recorded by Nazareth in 1975). It wasn't until late in the offline process that we muted the music track and discovered the drama associated with utilising sparse sound design only. The result is a sophisticated, smart 30 seconds of entertaining television that communicates a very simple message—'Tabasco Sauce is HOT'." Hal Dantzler, Producer

WASP

Centraal beheer

The insurance company in Apeldoorn.(055-798000)

AGENCY. Result DDB Amstelveen, 1999
COPYWRITER: Sikko Gerkema
ART DIRECTOR· Martin Cornelissen
DIRECTOR: Paul Vos
CLIENT: Centraal Beheer

Spectacularly shot, this ad is a proud link in a chain of legendary advertising for this dream Dutch client. Emphasising the idea of good insurance, no matter what the circumstances, it shows a unicyclist on a rope, trying to cross Niagara Falls. The panoramic scenes here are truly breathtaking. The plot gets thicker when a wasp lands on his cheek. So, how did this outrageously exaggerated insurance idea come about? According to the team, from a real wasp: "Sometimes it's the little things that make the best ideas. The creative team that worked on this project was having a drink outside on a sunny day when a wasp started circling around their table. One firm swipe sent the wasp tumbling into one of their glasses and the concept for this Centraal Beheer ad was born!"

AGENCY: Lowe Howard Spink London, 1992
CREATIVE TEAM: Chris Herring and John Merriman
DIRECTOR: Tarsem
CLIENT: UDV/Smirnoff

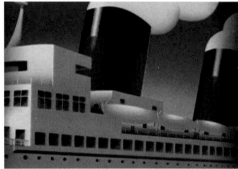

120 LINER

When it first appeared, we were stunned! Computers were still relatively new tools in the area of post-production in 1992 and the things that were to be seen in this ad were simply extraordinary. Taking place on the ocean liner ship, the ad was replete with surreal and decadent imagery—a staircase turning into piano keys, a cat turning into a black panther, exhaled smoke turning into a flame—all, of course, seen through a bottle of Smirnoff. From a production point of view everything was so seamlessly and perfectly glued together that new standards in computer imagery in advertising were set. This was the ad that contributed immensely to the agency credentials, director Tarsem's career and, of course, the brand.

SKOPJE JAZZ FESTIVAL 2000

AGENCY: Kompas Design
COPYWRITER. Slavimir Stojanović
ART DIRECTOR: Slavimir Stojanović
DIRECTOR: Slavimir Stojanović, Art Rebel 9
CLIENT: SJF, Oliver Belopeta

It's very hard to simplify jazz music into its purest symbol. This spot does just that. The five line stave system is the universal symbol for any kind of music. It appears slowly on the screen followed by moody swing music. When the note system is formed the fourth line starts twisting wildly followed by the characteristic trumpet sound. It straightens again, but in a different way to the other lines. Nothing is the same anymore. Just with one visual accent. That is jazz—individuality, improvisation, and a life of its own.

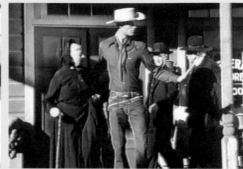

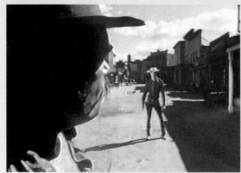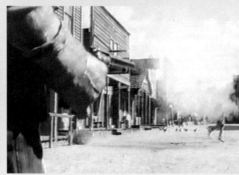

LITTLE ROCK

AGENCY: Paradiset DDB Stockholm, 1999
CREATIVE TEAM: Joakim Jonason and Jacob Nelson
DIRECTOR: Ulf Johansson/Traktor
CLIENT: Diesel

The quirkiness of Diesel campaigns has usually been confined to modern day settings and issues. However, in this hilarious spoof of western movies the plot is transferred to the past, but without losing the modern day connection. The plot is simply that "pretty" men don't always win against the bad, ugly and dirty ones. Even though the good guy helped ladies cross the road, had a stunning wife with a child and a clean and shiny gun, he finally bit the dust in a stand-off with a thoroughly dislikable, but amusing villain. In a way, this ad is a wonderful and brave statement against beauty and glamour in modern society. This ad was part of a series of two that won the Grand Prix in Cannes in 1999.

DIESEL®
JEANS AND WORKWEAR

123 5am MONO VILLAGE

AGENCY: Paradiset DDB Stockholm, 1999
CREATIVE TEAM: Joakim Jonason and Linus Karlsson
DIRECTOR: Ulf Johansson/Traktor
CLIENT: Diesel

The second part of the multi-awarded Diesel series. Here, the action takes place in a scout camp where the men are learning the art of mouth-to-mouth first aid. Instead of a beautiful girl volunteering to be at the receiving end of this exercise, the scout next in the queue has to face a bearded old man. He's appalled, yet when they kiss, a strange thing starts to happen: they're transported into a dream-like scene in which both of them act like a happy couple, surrounded by flowers on a sunny day. The end of the spot sees them riding together across fields, exchanging lovers looks. The ad is so full of campness that you either love it or hate it. Again, the controversial topic of homosexuality as an important social issue is covered here in the trademark Diesel style: off the wall, stylish and arty. A perfect brand building ad for a quirky and style-conscious audience.

WEEKEND OF TERROR

AGENCY: BSUR, 1999
CONCEPT: Joost Perik
COPYWRITER: Theo Doyer
DIRECTOR: Roger Beekman
CLIENT: Weekend of Terror
Film Festival

Who said sophisticated ads have to be either expensive or boring? With deceptively real drabness, this ad is a perfect example of the Dutch quirky sense of humour. Made from almost totally static documentary footage of a man closely examining a chest freezer in electrical goods shop, this award-winning ad implements the cheapest of TV technology—the security video. The old adage that if an idea is right, it should be possible to present it convincingly on a napkin springs to mind. It is a refreshing reminder that even the most monstrous things can be seen from a different perspective if processed with the right kind of humour. The answer appears in the last frame of the ad: Weekend of Terror, a festival of horror films!

JEANS STORY

AGENCY: Bates France, 1999
COPYWRITERS: Frank Rey and Pierre Pointeau
ART DIRECTOR: Aude Commissaire
DIRECTOR: Shaun Severi
CLIENT: Amnesty International

In 1999 Amnesty International chose "Human Rights in the USA" as its annual theme for its worldwide campaign. This 60-second film makes use of one of the most mythical American symbols, but certainly not in the context it has usually been associated with. A pair of jeans is dragged across asphalt, torn in a prison cell, attacked with an electric blackjack—a depiction of the most frequent human rights abuses perpetrated in the USA. The ad was shot in a dramatic way, with dim light and muted colour, creating an atmosphere of claustrophobia and repression. The USA has already started to take action following this campaign and this action is spreading. "The problem posed by Amnesty International was to communicate to French people the American paradox which is that a first world country is currently violating human rights on its own territory. The solution we found was to use a strong and positive symbol of American success: that's how we decided to use a pair of jeans, in order to denounce the most frequent human rights abuses perpetrated in the USA." Frank Rey

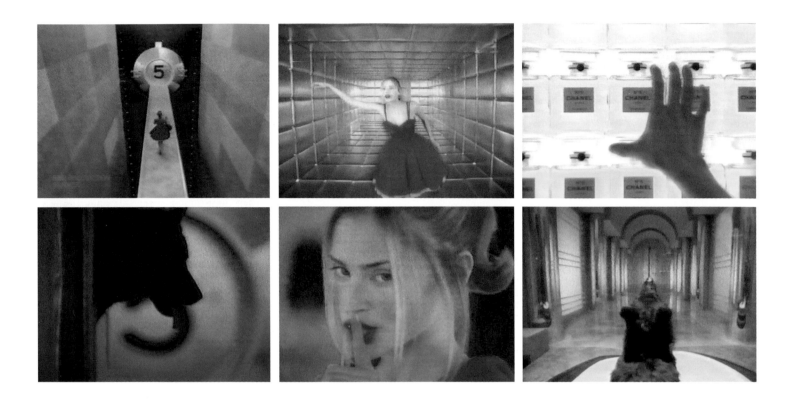

RED RIDING-HOOD

AGENCY: BDD Production, Paris, 1999
DIRECTOR: Luc Besson
CLIENT: Chanel

A polished interpretation of the story of Little Red Riding-Hood, with all the Paris catwalk style and sex appeal. Endless rows of perfume bottles stored in a secret vault. A mystical connection between the girl, the perfume and the guarding wolf. The wolf howls helplessly at the end, forced to obey the beautiful girl as she takes a bottle of perfume off into the glittery Paris night.

Chanel—Commercial Ad N°5—1999.

VAN GOGH

AGENCY: Ammirati Puris Lintas Warsaw, 1997
COPYWRITER: Chris Matyszczyk
ART DIRECTOR: Ray Knox
CLIENT: P. Voigt Opticians

Unable to wear glasses due to the lack of one of his ears, this artist—a clever take on Vincent Van Gogh—finally loses his temper and smashes them to pieces. An extremely persuasive ad promoting the use of contact lenses instead of glasses. A perfectly pitched story.

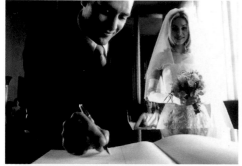

WEDDING

AGENCY: Jean & Montmarin, 1999
COPYWRITER: Benoit Schmider
ART DIRECTOR: Thierry Chantier
DIRECTOR: Christian Lyngbye
CLIENT: Bouygues Telecom/Nomad

A bit of a radical way to promote a telecom company, this story unfolds with a newlywed couple starting to make love passionately. After consummating the marriage the bride goes to the toilet and, to the profound horror of her groom, demonstrates some rather unusual and unfeminine toilet-using skills. A question: what does this have to do with a telecom company? An answer: choose your partner well. According to the creative team, the thought process went like this: "To illustrate the commitment, we searched for the nicest symbol of it: the wedding. And then we searched for the worst thing that can happen to you on the most beautiful day of your life: to discover that the woman you love and have just married is a man. In the final scene, people always ask: is it a woman or a man? Even we don't know."

BET ON BLACK

AGENCY: AMV BBDO London, 1999
CREATIVE TEAM: Tom Carty and Walter Campbell
DIRECTOR: Frank Budgen
CLIENT: Guinness

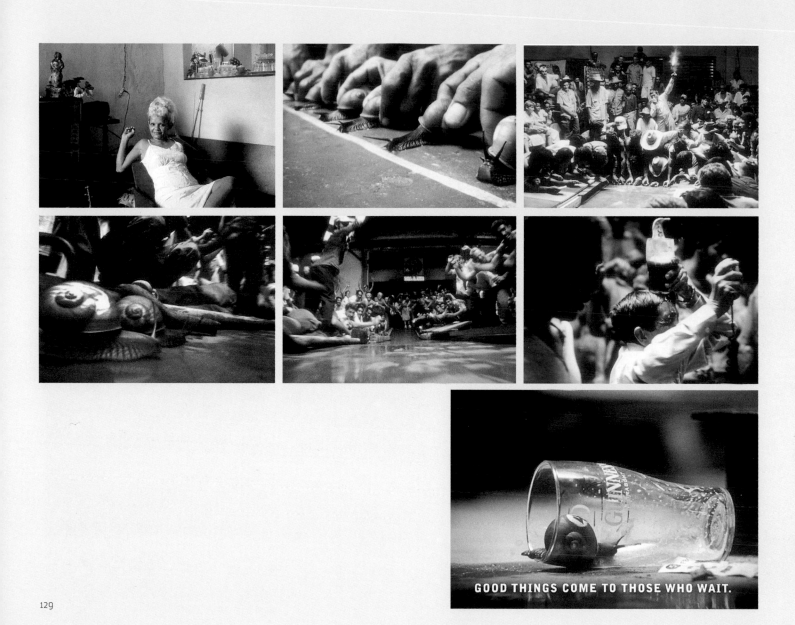

GOOD THINGS COME TO THOSE WHO WAIT.

Shot in Cuba, and perfectly reflecting the colour and mood of the country, this ad had a couple of bizarre moments during production of this snail-racing saga. One of the best, apart from searching for the right snails, was probably when the cast—genuine Cuban villagers—gathered on the set wearing their best and cleanest clothes to celebrate the occasion and to honour the TV people. The director, though, wanted them in their regular, everyday soiled shirts. The villagers were a bit puzzled. The creatives—Tom Carty and Walter Campbell—however, had some other things in mind: "The influences for Bet on Black were pretty obvious. The Grand National, The Indianapolis 500, and the chariot race in Ben-Hur. We thought what could we do to make fun of these spectacles without totally defusing the excitement? Snails seemed like a good area, very original, very surreal. About two months later we found out that people actually do race snails. That's life!"

THE LAST LAUGH

AGENCY: inch up effekt bureau Vejle, 1998
CREATIVE DIRECTOR: Soren Palmelund
DIRECTOR: Ulrik Jensen
CLIENT: Agfa

Early in 1998 Agfa in Denmark had a market share below ten per cent. Generally, they had a hard time getting listings in the shops, but they were on the right track and ready to invest in the market. This ad helped the company turn its luck around. The agency explains the approach: "In general there's not much to choose from in the film you use. It is difficult to differentiate your brand in a trustworthy way. It was essential to communicate that the product could provide more than just 'simply' taking a picture. Therefore this ad was produced. The goofy guy manages to take a picture under water of the teasing girls waving their Bikini bottoms around.

Hence the last laugh: the person using Agfa always gets the last laugh or to be more precise, Agfa ensures that the user gets the picture he or she wants."

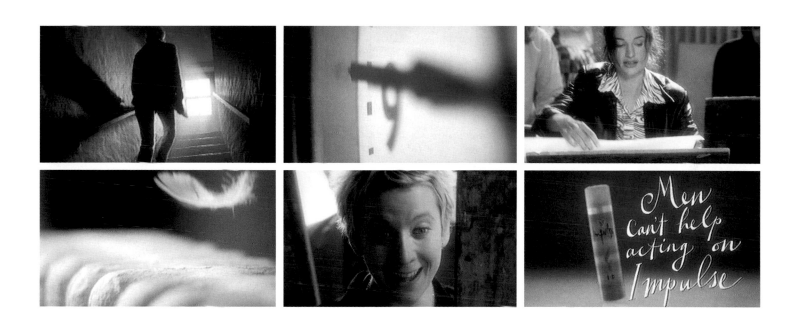

ART SCHOOL

AGENCY: Ogilvy & Mather London, 1999
COPYWRITER: Justin Hooper
ART DIRECTOR: Christian Cotterill
DIRECTOR: Jeff Stark
CLIENT: Impulse

The story of this saucy TV ad is simple: during an art class, in which a gorgeous nude male model (not shown here because of copyright issues) is posing to the class, a girl arrives late. As she walks by the model, her deodorant proves so sexy that he gets aroused, which is cleverly emphasised in the ad by several objects being moved from a low position to a high position (a feather above the radiator, a clock hand going upwards). Of course, the class starts giggling and applauding. The rationale behind the ad is based on some very important strategic considerations, explained here by the creative team: "The Art school ad is part of the broader Impulse story which throughout the nineties has been about the rejuvenation of a tired old brand. The pre-nineties portrayal of romance and boy/girl relationships had become as relevant as a Catherine Cookson novel. For the brand to succeed it needed to prove it understood the dynamics of romance in the nineties. A major research project wittily titled 'Romance in the nineties' provided the catalyst for a radical change in direction. The portrayal of women as passive victims, preyed on by men was clearly deeply inappropriate. As were flamboyant empty gestures lacking imagination and sincerity, e.g. the gift of an over-the-top bunch of flowers. Research showed that women are confident and increasingly in control of their relationships. The breakthrough was the discovery that flirting with a stranger was one of romance's greatest thrills. It may lack depth but flirting is fun and involving. This idea, supplemented by a definite role for the product—Impulse is the trigger for the boy/girl attraction—gave us the executional structure. 'Art school' was the first ad that really expressed this and it allowed the girl, the heroine, to become dynamic, gregarious, self-confident and independent. In short, she was aspirational, Impulse was aspirational."

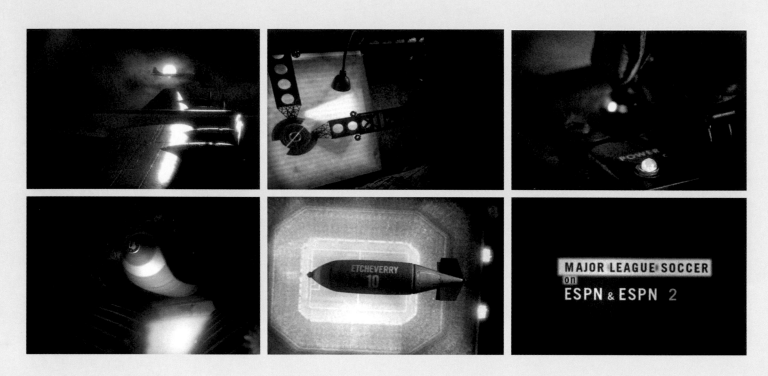

BOMB

AGENCY: Ground Zero Santa Monica, 1999
COPYWRITER: Daniel Chu
ART DIRECTOR: Gavin Milner
DIRECTOR: Mark Wurts/Miss Jones Creative Team
CLIENT: ESPN Sports Channel

Marco Etcheverry was a midfield player for US soccer team DC United until early 1999. He gained the nickname "The Bomb" because of his devastating presence on the field, inspiring at the same time this homage TV spot. Made for the sports channel ESPN, the director used footage of a pilot filmed in front of a blue screen married with a computer-generated cockpit, bombing bay and soccer stadium. The final result is a film with the feel of a Second World War bombing mission and a reminder of the truism that great players are essential to building a game's image.

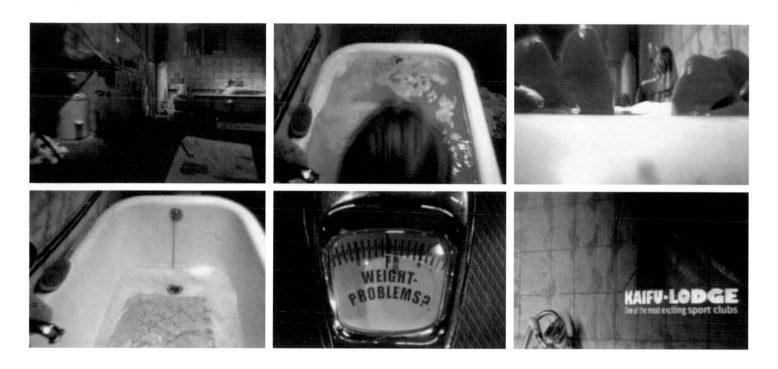

BATHTUB

AGENCY: Jung von Matt Hamburg, 2000
DIRECTOR: Markus Walter
CLIENT: Kaifu Lodge Sport Clubs

Although the ad was to be shown at cinemas and on TV in the Hamburg area only, it certainly has all the marks of a top-rate production. Even more outstanding, almost everything in the ad was done in-camera, without the use of an expensive computer during post-production.

The bag of tricks included staples of modern video like tilt- and shift-lense effects and even one unmounted snorkel optic. The latter was shaken and swivelled in front of the camera to play around with the focus and produce visual tension. The story is about a woman who gets into a bathtub, spilling water over the edge. When she gets out, the level of water drops to just cover the bottom of the bathtub—the lady has a pretty voluminous body. The final line reveals that for all sorts of weight problems, Kaifu Lodge sport clubs are the place to go.

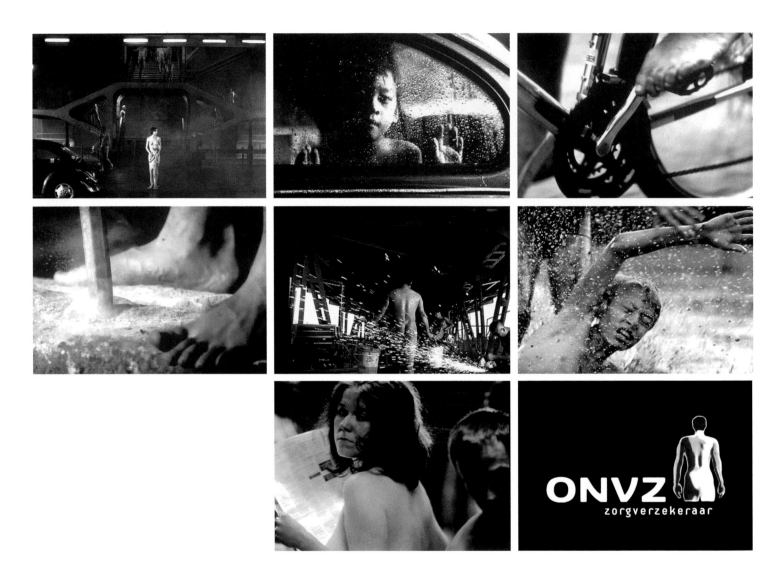

134

YOUR MOST VALUABLE POSSESSION

AGENCY: KesselsKramer Amsterdam, 1998
COPYWRITER: Johan Kramer
ART DIRECTOR: Erik Kessels
DIRECTOR: Rupert Sanders
CLIENT: ONVZ Health Insurance

"Life moves pretty fast indeed. Sometimes we forget how truly fragile our bodies are in the face of heavy industry and the societies we've constructed around us. The film demonstrates our fragility in the modern world, and how we mostly feel impervious to accident even when danger is close. Moments in the film show how genuinely delicate and exposed our bodies are in the everyday world. These moments are shot in slow-motion black and white, and reflect instances of day-to-day life. But, in order to emphasise our vulnerability, each person in the film is completely naked. This is because when we wear clothes we protect ourselves. We mask our fragility and feel safe. But clothes only cover us. Underneath, we are still flesh, bone, muscle, organ, blood, corpuscle, tissue, heart, breath, and a pulse. When we are naked we become conscious of our many weaknesses. We are aware of our delicate bodies, organic and soft in an industrial world of heavy machinery. We realise how precious life is surrounded by all these powerful mechanisms," KesselsKramer creative team explains.

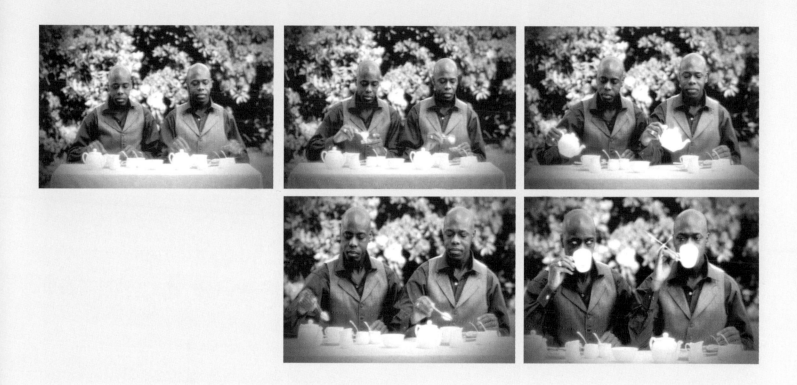

TWINS

PRODUCTION COMPANY: MAP Films
COPYWRITER: Tony Esslinger
DIRECTOR: Tony Esslinger
CLIENT: Visions/Media Trust/Channel 5

The brief for this ad was just that: brief— "Respecting Difference". So, to the sound of "Tea for Two", twins take tea and scones in an English garden full of flowers. The difference between them is the tendency of one to raise his right pinky while drinking. Tony Esslinger, the creator of the ad, explains the approach: "Films dealing with cultural and race discrimination are usually hard hitting and serious. We wanted to buck this trend and use a light hearted approach. We took a positive view of 'difference'. Thank goodness we are all different. This difference is something to celebrate not fight about—'Vive la difference!'. Imagine a world full of clones. By using identical twins we could demonstrate how even those of us that are most alike, are different. It's a relief to discover this difference." The ad was shot as an ironic example of extreme similarity and synchronised movement, using real twins, rather than the same actor filmed twice.

MILK

PRODUCTION COMPANY: dweck! New York, 1999
COPYWRITERS: David McDuffie, Michelle Rouffa
and Deacon Webster
ART DIRECTOR: Carol Holsinger
DIRECTORS: Tom Kuntz and Mike McGuire
CLIENT: UPN

What is happening in this ad is the following. The setting is a UPN Television Satellite Outpost, late at night. Everything is running okay. Employees are bored to death. One of them tries, but fails to impress his colleague by taking a big sip of milk, stretching cellophane across his face, and expelling the milk from his mouth. Crazy? Yeah. David McDuffie explains it all: "This commercial is from an on-air branding campaign for UPN, Paramount's broadcast TV network in the United States. If you're not familiar with them, it probably bears some explanation. We helped UPN reposition themselves for a young male audience, with quality programming like, umm, pro wrestling. We didn't want their communications to claim this new position. We wanted their communications to be it. We wanted to do stuff the target audience could most relate to, and slap a logo on it. Which, it seems, was stretching sandwich wrap across someone's face and having milk spray all over the place. Apparently guys did this to 'be cool', and gross out (and impress) the ladies in the lunch room when art director Carol Holsinger was in junior high school." David also had a comment on the book: "I'm not so sure I agree with the premise of this book. Writing is critical too, very critical. As you can see, we needed three writers to complete this spot. In the end, I wrote the 'U', Michelle wrote the 'P', and Deacon was having problems with the 'N', so Michelle and I helped out. And then we took a very long coffee break." Nice ending.

PEEP SHOW

PRODUCTION COMPANY: New Moment—Ideas
Campus Piran, 1998
COPYWRITER: Dragan Sakan
ART DIRECTOR: Boris Miljkovic
DIRECTOR: Boris Miljkovic
CLIENT: New Moment Magazine

New Moment is a magazine dedicated to art and advertising which serves as a cutting-edge cultural window between West and East (in a sense of Eastern and Central Europe). Design and content are usually of a very high standard and are accompanied by provocative ads, trying not just to promote the magazine but to make a statement on relationships between the two, until recently, separated parts of Europe. The metaphor used in a pivotal 1998 issue was one of a "peep show", pointing to the then still nature of East/West cultural exchange in the light of a post-communist era. The ad shows two men, peeping at each other through a narrow slot, puffing and sweating. The music is strong blues/rock often associated with strip bars. Eventually, it is clear what they are doing: they are pleasuring themselves sexually while peering at one another. Ironically this becomes a metaphor for the sometimes superficial understanding the two parts of Europe have of each other, as well as the abuse of stereotypes during the Iron Curtain era.

BENJI
JASON

AGENCY: Ehsrealtime London, 2000
COPYWRITER: Paul Moulton
ART DIRECTOR: Don Lindsey
DIRECTOR: Olly Blackburn
CLIENT: dotmusic.com

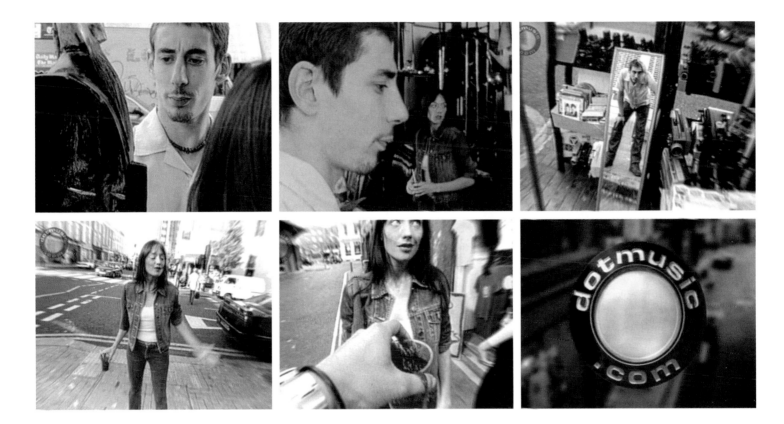

Dotmusic.com is the largest European music site catering for a wide variety of musical tastes and inclinations. Their wish and ability to experiment and use communications that are innovative and compelling, lead to a distinguished series of three TV ads—one of the most prominent dot.com campaigns in the UK in the last couple of years. Paul Moulton, the copywriter on the campaign, explains some behind-the-scene details: "There's nothing more individual than people's musical taste. That was our starting point for these ads. The title was 'Soundtrack for Life', and was based on the idea that everybody has their own unique soundtrack going on in their heads at any one time. Using the strap-line 'What's your sound?' the spots sought to show the soundtrack inside the heads of three music lovers. The special effect/whiz bang gizmo we used to get this feel involved a physical journey inside the ear and out through the optic nerve. After that the rest of the spot was from the point of view of the camera. But for us the most important element was the music. We rejected existing and popular music in favour of a specially composed soundtrack that could weave around and react to events that happened outside of our heroes. The 'Benji' spot was heavily flavoured by hip-hop, 'Jason' by indie/rock and the third one, 'Lara', by good old pop. This variety also helped to show the eclectic nature of the dotmusic website. We shot all three ads at the speed of light over four days. Then we lay down for a bit."

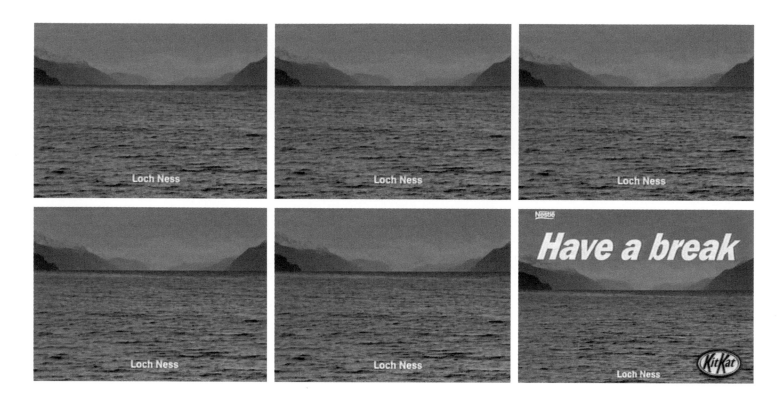

LOCH NESS

AGENCY: J Walter Thompson London, 2000
CREATIVES: David Mackersey and Siggi Halling
PRODUCTION COMPANY: BFCS Ltd
DIRECTOR: Simon Drewitt
CLIENT: Nestle UK/Kit Kat

As simple as it gets and yet very clever. The ad opens up with a static shot of Loch Ness without any background music or voiceover, just lake sounds. As footage of one of the most famous lochs in the world, one expects all sorts of monster-related suspense-building situations and twists. It turns out that there is none of this, just clever tongue-in-cheek irony: when the strap-line "Have a break" appears it is clear that the lake was used just as a metaphor for a relaxed and quiet surrounding, tying it up with the product strategy. The "Loch Ness" title was just a teaser. The spot is from the very successful series for this product, all made in the same ironic manner. It is a refreshing step forward from the usual blunt "kids-want-to-have-fun" way of advertising confectionery. Also, once again proof that nothing is as arresting on the TV screen as silence used properly.

now 10% more free

TREE

AGENCY: Leo Burnett Lima, 1999
COPYWRITER: Jose Luis Rivera y Pierola
ART DIRECTOR: Juan Jose Castillo
DIRECTOR: Jorge Salinas
CLIENT: Procter & Gamble Peru

Joyfully simple, this ad features static footage of a housewife getting ready to hang the washing out to dry. The washing line is stretched between the house and a tree. However, she starts digging a hole around the tree, then another hole a little further away, and finally pulls the tree out and moves it into the new hole. The rope is now longer. The reason for this is that new Ace washing powder lasts longer. An intelligent idea, gripping from the start because of its simplicity and underlying absurdity. Proof that ideas, not always big production budgets, are what count in the never-ending advertising game.

CAR WASH

AGENCY: BMP DDB London, 1999
COPYWRITER: Clive Pickering
ART DIRECTOR: Neil Dawson
DIRECTOR: Johnny Maginn
CLIENT: Shu Uemura lipstick

This drama is unfolding between a car, a man and an unknown, unseen, but implied female person. A new and expensive white BMW is in a car wash due to the desperate attempt by its owner to wipe something off the car. He tries once, then a second time, and then even a third. It is obvious, from the desperate look on his face, that it hasn't worked. Powerless to do anything, he stares at the car's door covered with huge letters spelling "Bastard" written with lipstick. But not any lipstick—Shu Uemura, a long-lasting one. In a way, this is USP advertising, but like many other ads seen in this book, an extremely intelligent USP ad builds brand like crazy. The plot is set up extraordinarily well for the given target group—it's almost possible to hear cheers of approval from the better, prettier and sexier half of the world.

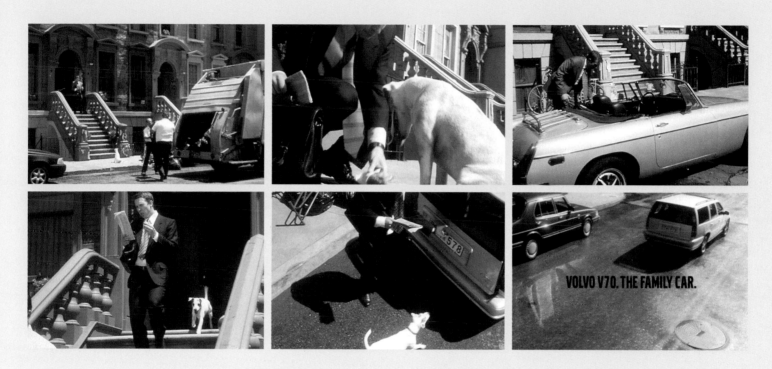

VOLVO V70. THE FAMILY CAR.

STRAY DOG

AGENCY: Forsman & Bodenfors Goteborg, 1999
PRODUCTION TEAM: Oscar Askelof and Filip Nilsson
PRODUCTION & DIRECTION: Traktor
CLIENT: Volvo Cars Sweden

How to define a family, especially if you are trying to sell a family car? In this ad the approach is unusual: every morning a young "yuppie" type comes out of his building to be faithfully greeted by a stray dog. The relationship slowly develops, first through a sandwich the guy starts sharing with the dog and finally by changing his car, from a sporty two-seater to a family-sized Volvo. The creative team experimented with various definitions of a family: "We decided quite early on to acknowledge the fact that the Volvo V70 is a family car. Creatively, the challenge was to ignore all 'end-of-exciting-youth' associations that come with that territory and interpret 'family' in other ways. After all the more or less obvious Mafia metaphors, we ended up with the yuppie and his stray dog." Although created by a Swedish agency, the ad has a distinctive British feel to it, largely due to the Madness song "It must be love" that was the musical background.

THE NINETIES

BALKAN TANGO

AGENCY: Hammer Creative Novi Sad, 2000
COPYWRITER: Milos Jovanovic
ART DIRECTOR: Balaz Eduard
DIRECTOR: Milos Jovanovic and Szilard Antal
CLIENT: Djordje Balasevic

The background story of this grim but powerful political statement deserves an explanation. Djordje Balasevic was the greatest poet-musician in the former Yugoslavia and a good will ambassador for the UNICEF. On his most recent CD, published shortly before the Yugoslav revolution that ousted Slobodan Milosevic, he has made a retrospective of all major events in the countries of former Yugoslavia during the past ten years. It is a strong, albeit disillusioned account of the devastation of a country. All songs come under the common title of THE NINETIES (with "Fuck off nineties" as a subtitle). Writing about war, love and hope, the artist paints the portrait of the years characterised by devastation. In this blurred ad for the CD, Hammer Creative have shown a tango dancer, passionately trying to perform, but constantly stumbling and falling out of the frame. Only the last shots reveal that he actually has one artificial leg, tragically colouring his artistic efforts. It is a metaphor for a ruined country, for passion and apocalypse mixed together, for many thousands dead and mutilated, but also a desire for living.

THE FUTURE IS IN YOUR HANDS

AGENCY: JDA Perth, 1999
COPYWRITER: Matt Cullen
ART DIRECTOR: Gary Tranter
CLIENT: Keep Australia Beautiful Council (Western Australia)

What happens in this beautiful but strong and thoughtful environmental story is a lesson in dramatic poetic. It shows a man, driving into the sunset, with a cigarette in his hand. He drops the cigarette when finished with it. Instead of a cigarette falling to the ground, we see a dead bird falling. With each thing carelessly thrown away by people, another animal falls down dead. It really seems, as the agency creatives point out, that the fate of our environment is in everyone's hands. This ad hits home with impact. "Keep Australia Beautiful Council (Western Australia) provides leadership which strives for a litter-free, beautiful and environmentally healthy Western Australia. JDA proposed that KABC(WA) should adopt a strategy to reach the broad community with a simple and consistent message demonstrating how the fate of our environment is in everyone's hands. This idea was communicated with the message, 'The future is in your hands'. Our task was to harness feelings of care people claimed to have for the environment and to translate this into caring behaviour. We believed this could be best achieved by a dramatic approach which clearly demonstrated the negative impact littering has on the wildlife that shares the environment with us."

MANIX® 002
The world's thinnest condom.

FINGERPRINT

AGENCY: BDDP & Fills Boulogne-Billancourt, 1999
COPYWRITER: Bruno Delhomme
ART DIRECTOR: Damien Bellon
DIRECTOR: Vroegrop Franck
CLIENT: Ansell/Manix Condoms

Another brilliant example of the so-called "napkin" idea—so powerful, yet so simple that it could be drawn on a napkin. At the same time, a brilliant example of a USP ad, in this case stressing how thin Manix condoms are. Very engagingly shot and adding very knowledgeable directorial touches to a simple idea, the ad opens up with a flying packet of condoms landing into someone's hand. The packet is opened and, surprisingly, the condom is put on a finger which in turn is rolled on an ink pad. The finger is then pressed against a sheet of white paper leaving a clear fingerprint mark, as if there weren't any barrier between the finger and the white paper at all. The message is clear: Manix condoms are so thin you won't notice it. Powerful simplicity.

SHAKE BEFORE USE

AGENCY: FUTURA DDB, 2001
COPYWRITER: Zoran Gabrijan
ART DIRECTOR: Benjamin Ivančič
DIRECTOR: Gregor Vesel
CLIENT: Radenska

"Because ACE is a large brand with many different types of drinks, we chose to go with a general concept of shaking the drink before use. Because it's made from natural fruit juice that seemed like a perfect solution for a long-term advertising campaign. Because the potential customer base is really large and varied, we used a visual approach rather than a 'long-explanation-give-me-a-break' one." The guy in the fridge is shaking, of course.

Interactive pictures

No-Copy

Advertising

INTERNET

WON'T OPEN

AGENCY: BMP DDB, London, 1999
COPYWRITER: Ed Edwards
ART DIRECTOR: James Townsend
CLIENT: Volkswagen

If you need a perfect example of the ability of one legendary client (and its agency) to transfer magnificent offline advertising online, here it is. It's interactive, it's ingenious, it's quality "viral marketing", and it's brand-building. When you click on the "open" button nothing happens.

DOTMUSIC.COM

AGENCY: Ehsrealtime London, 2000
DESIGNER/DEVELOPER: John Hatfield
and Jeff Hanbury
CLIENT: Dotmusic

A brilliant piece of planning insight very often is the basis for innovative ads or campaigns—it is certainly the case here. Otherwise tedious loading time is converted into a powerful branding exercise, with a direct response as an added benefit. Using DHTML technology, the team designed a "mouse tracker" web ad, consisting of nothing but the Dotmusic name and a logo following the pointer on the screen as you move it. You can see different phases of this in the screengrabs above. The site page design is a bit cluttered, but it actually helps the ad work very well in its live form. It's elegant and eye-catching. If you click on a "badge"—and it takes a bit of skill to catch it, which makes the ad feel like a small game—you are transferred to the Dotmusic website. If you have ever asked yourself how sticky your mouse pointer can be (and we usually don't think about it that way) here's a great example. "What was required was a simple engaging device to increase awareness of the brand. We noticed people are forever playing with their mouse like they twiddle a pen. This creative ad rewards them with an effect."
John Hatfield and Jeff Hanbury

152 M A Z E

AGENCY: Digerati Johannesburg, 2000
ART DIRECTOR: Philip Ireland
DESIGNER/DEVELOPER: Walter Jones
CLIENT: Land Rover

For all those involved in the current debate over whether the web banner is dead or not, just take a look at this one! What starts as an almost anodyne, "now-we-are-going-to-use-a-maze" trick that is seen in hundreds of banners all over the net, turns out to be one of the most hilarious visual puns in the depreciating world of online banner advertising. Quite unexpectedly, instead of reluctantly going through the maze the Land Rover vehicle drives right through the hedge walls, in one straight line, conveying the true spirit of the brand. What is even more amazing is that this banner stays within the technological and design limits of a traditional banner execution, showing that online, as well as offline, it is not just the technology (production) that counts, but a big idea.

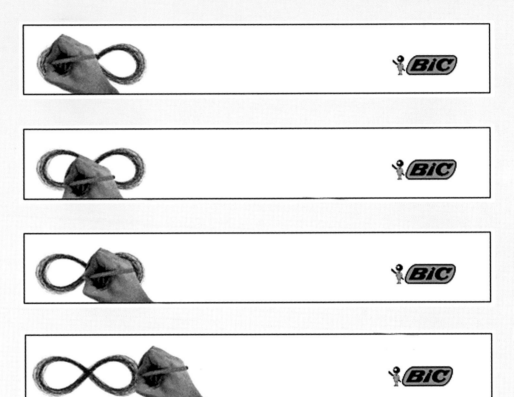

INFINITY

AGENCY: Digerati Johannesburg, 2000
ART DIRECTOR: Jan Jacobs
COPYWRITER: Claire McNally
DESIGNER/DEVELOPER: Tim Jones
CLIENT: BIC

It is not often that you can translate a press ad execution online quite literally and still allow it to be as engaging and ingenuous as the original. However, this is exactly what this banner has achieved. With just the addition of the simple animated continuous movement of writing the "infinity" sign, the banner brings to life the perceived long life of a BIC pen as impressively portrayed in a print ad on page 48. Everything here depends on a great idea. Technical execution is almost old-fashioned, at least compared to various "bells and whistles" being used on the net more and more these days. Just a couple of .GIF frames, simply looped. However, that simplicity actually helps convey the message and not get in the way of the idea. Note the clever use of a white background, making the animated part stand out even more, as if it is breaking through the banner format, on an average (white) portal site page.

FLAT ERIC

AGENCY: Lateral London, 1999
EXECUTIVE PRODUCER: Jon Bains
CREATIVE DIRECTOR: David Jones
PROGRAMMER: Robert Tingy
CLIENT: Levi's

This particular execution was a continuation of one of the biggest fads in advertising in recent time. "Flat Eric" TV ads are legendary and the theme song from the ads hit the charts and went to number one! The main character, a puppet called Flat Eric, is cool and a bit zany, and together with his human buddy finds himself in various awkward ad situations which present some of the more tangible aspects of the product (i.e. perfect creases). What was needed was an extension of the hype into the digital domain, the same quirkiness of appearance and idea that shaped and helped offline executions capture the vibe of the market. This London campaign introduced so-called "overts", another example of the DHTML technology which showed Flat Eric slowly moving across, or down, the screen, over the content of the page. It was interactive as well, meaning that if you click on it, it will lead to a specially designed site. When it appeared, the ad shocked the UK web development community with its freshness and novelty, spinning many of the interactive designers and developers into sleepless nights trying to figure out how it was done. Then came the imitations, of course.

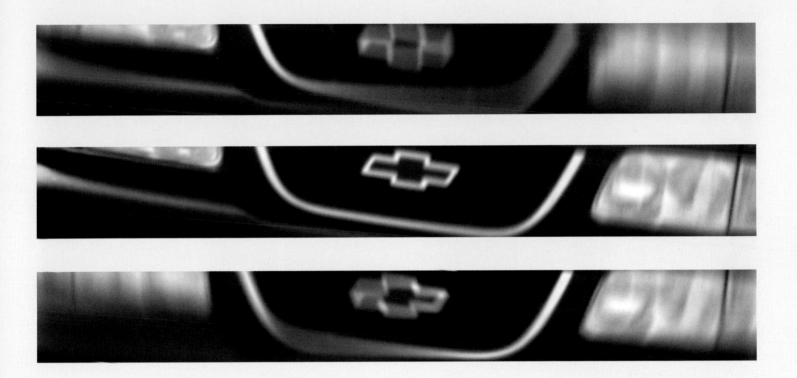

SHAKE

AGENCY: AgenciaClick Sao Paulo, 1999
COPYWRITER: P. J. Pererira
ART DIRECTOR: Edwin Veelo
CLIENT: General Motors of Brazil

Isn't the essence of driving off-road, especially in a pick-up truck, being shaken to pieces? Then that's what the "internaut" (that's what Edwin, the art director, calls a web surfer) needs to experience. But how to do that? Using Adobe After Effects, a shaking car was created from a still image. "I've always believed that limitations stimulate creativity," said Edwin. "That's what enticed me to the web in the days of Mosaic and Netscape 1. Those limitations, compared to what we can do right now, seem tremendous. And yet I almost long for those days because of the few options that were available. But even with all the possibilities we have today, the limitations for communicating an emotion through a banner are even greater, and so is the stimulation for creativity. When you know the limits, you have defined your box, so you can start thinking outside of it. Promoting a car within the box would be showing the car, the logo, the headline; talking to the internaut within the limited space available. Now take him away from his web environment, put him inside the car; let him experience how driving an off-road can really shake up his world. That might be outside the box. The solution: no need for a headline (the pick-up bouncing over rough terrain is a much stronger carrier of the emotion than words). No need for placing a logo (it's already on the car). And, all options were used to shake up the user's world, even his entire browser window shakes when he moves his cursor over the banner."

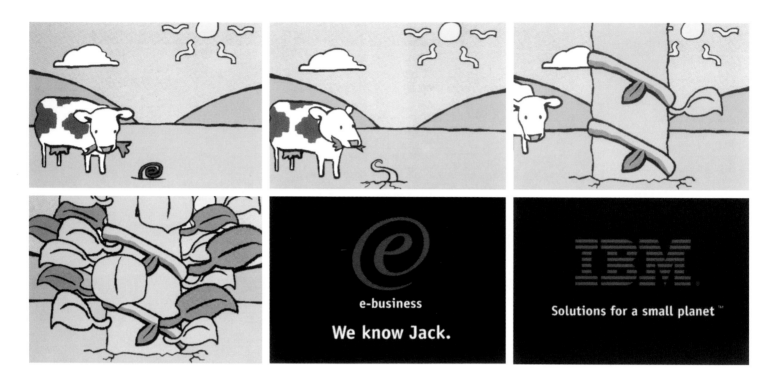

WE KNOW JACK

AGENCY: Icon Nicholson, 1999
ART DIRECTOR: Britt Funderburk
COPYWRITER: Britt Funderbruk
DIGITAL ARTIST: John Kaurderer
MULTIMEDIA: Jiro Ietaka
CLIENT: IBM

IBM wanted to position itself as an innovator on the web and demonstrate its relevance to a college/young executive target. The company hoped to get on the "radar screens" of what was often considered the "Microsoft Generation". So, Nicholson NY was brought in to convey IBM's technology leadership to this young audience. Nicholson chose to develop an engaging, clever design combining audio, eye-catching illustration and animation to create an awareness of IBM's e-business solutions. The agency partnered with "You Don't Know Jack", a targeted, leading-edge entertainment site, to help deliver a dynamic, multimedia message. The result was an interstitial "with attitude". (An interstitial is an Internet ad showing while you jump from page to a page.)

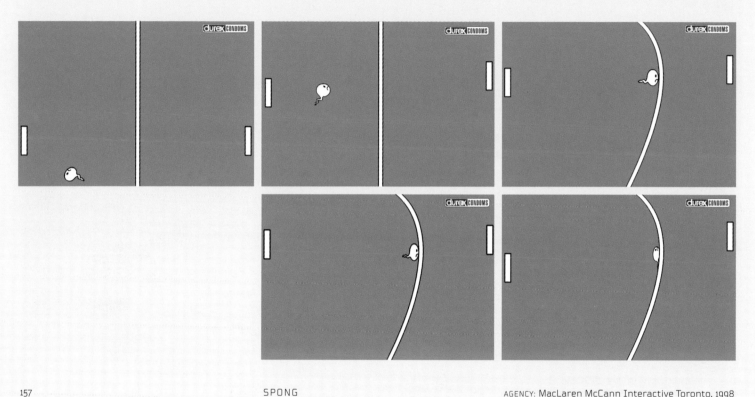

SPONG

AGENCY: MacLaren McCann Interactive Toronto, 1998
COPYWRITER: Jonathan Freir
ART DIRECTORS: Mike Halminen and Sean Davidson
TECHNICAL DEVELOPER: Shawn Pucknell
CLIENT: Durex Canada

A couple of years ago (although for many Internet users it is still the same today) screensavers were the big hype on the Internet. Everyone was downloading them and many agencies and developers were competing to see who could come out with the most hilarious one. Given the fact that screensavers are present on an individual's desktop sometimes for a quite considerable amount of time, it was just a matter of time before they began to be used as an advertising tool. Following an award-winning print campaign for Durex Canada, the interactive arm of the agency came up with this excellent screensaver joke that won commendation in one of the D&AD award shows. Parodying one of the oldest computer games, "Pong", the agency designed "Spong", in which a desperate spermatozoid can't bounce from plate to plate because of a membrane in between. Association is quite obvious, but the execution delivers big time and makes this ad one of the finest examples of what branding can mean in digital space.

GUITAR

AGENCY: Freestyle Interactive San Francisco, 2000
PROGRAMMERS: Keith Neal, Steve Von Worley
CREATIVE DIRECTOR: Mike Yapp
CLIENT: Sonic Net

A simply superb use of the expressive powers of Internet technology. This banner has several chords programmed into it and marked on a guitar neck. Using your mouse to operate the picture of a pick, also placed within a banner, you can literally strum the guitar's strings in the chord chosen. The sound effect is very realistic. There is an option to play all of the chords automatically, tied into a small musical loop, or to play the chords manually as a tune and with a certain rhythm. It is in effect a clever musical game. Compared to many offline ads, interaction time between the user and the banner is in a league of its own. Try it out for yourself!

SCREEN SHUNTER

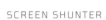

AGENCY: Ehsrealtime London, 2001
COPYWRITER: Jane Rajeck
ART DIRECTOR: Nicole Adams
DEVELOPERS: David Joss, Mark Dawber
and John Hatfield
CLIENT: Splash Plastic

Developed for Splash Plastic, an online card-payment facility provider for students and other young customers, this ad is another example of clever and witty use of the DHTML technology. After clicking on the client's banner or other link, the Splash Plastic mascot comes on to the screen, bouncing back and forth all over the place. Suddenly, the character pushes the left side of the screen and the whole screen content moves left, leaving empty space on the right. This is repeated several times, providing a wonderful element of surprise and "wow" factor to the ad.

Another great example of the new effects and creative capability brought about by Internet technology and used to heighten the impact of online advertising.

INDEX